MARTIN PURYEAR

Margo A. Crutchfield

VIRGINIA MUSEUM OF FINE ARTS

Richmond

This catalogue was published in conjunction with the exhibition *Martin Puryear,* organized by the Virginia Museum of Fine Arts.

EXHIBITION TOUR

Virginia Museum of Fine Arts
Richmond, Virginia
March 6 – May 27, 2001

Miami Art Museum
Miami, Florida
June 22 – August 26, 2001

University of California Berkeley Art Museum
 and Pacific Film Archive
Berkeley, California
September 12 – December 30, 2001

Seattle Art Museum
Seattle, Washington
January 17– April 21, 2002

Library of Congress Cataloging-in-Publication Data

Crutchfield, Margo A.
 Martin Puryear : exhibition venues, the Virginia Museum of
Fine Arts, Richmond, March 6–May 27, 2001 / Crutchfield, Margo.
p. cm.
 ISBN 0-917046-58-7
 1. Puryear, Martin, 1941—Exhibitions. I. Virginia Museum of
Fine Arts. II. Title.
NB237.P84 A4 2001
730'.92—dc21 00-013026
 CIP

ISBN 0-917046-58-7
Printed in the United States of America

Produced by the Office of Publications
Virginia Museum of Fine Arts
2800 Grove Avenue, Richmond, Virginia 23221-2466 USA
Distributed by: University of Washington Press, P.O. Box 50096,
 Seattle, Washington 98145-5096
Project Editor: Rosalie West, with the assistance of Anne Adkins
 and Jenifer Buckman
Graphic Designer: Sarah Lavicka
Composed in Frutiger by the designer in QuarkXpress
Printed on acid-free 100 lb Strobe Dull by Progress Printing,
 Richmond

FRONT COVER: **LADDER FOR BOOKER T. WASHINGTON**
(detail), 1996, ash (cat. no. 7). Collection of the artist.
PAGE X: **BRUNHILDE** (detail of interior view), 1998–2000,
cedar and rattan (cat. no. 12). Collection of the artist.
Photos by Katherine Wetzel. © Virginia Museum of Fine Arts.

CONTENTS

FOREWORD

The Virginia Museum of Fine Arts is pleased to present this exhibition of current work by Martin Puryear, one of the great sculptors of our times. While his sculptures can be seen individually in prominent museums in the United States, the opportunity to view such a major group of his work is rare indeed. This exhibition is the artist's first to take place in American art museums in almost a decade.

This exhibition brings together for the first time superb examples of Puryear's work from 1989 to 2000, including sculptures that have never been exhibited before. These extraordinary objects—some monumental in scale—are commanding in the power they exert over our imaginations and in the space they require. In Richmond, we are pleased to dedicate more than 8,000 square feet to this work and are proud to continue our long history of commitment to contemporary art in this way.

We are privileged to bring Puryear's work to audiences in Virginia and around the country. For their participation in the exhibition tour, we are grateful to Suzanne Delehanty, Director of the Miami Art Museum; Kevin Consey, Director of the University of California Berkeley Art Museum and Pacific Film Archive; and Mimi Gardner Gates, Director of the Seattle Art Museum. Special thanks must go to Margo Crutchfield, the Virginia Museum of Fine Arts Associate Curator of Modern and Contemporary Art, for her unswerving dedication as curator of this exhibition. I would also like to thank the many other talented Museum staff members responsible for bringing this project to fruition.

Without the extraordinary generosity and support of the National Endowment for the Arts, Robert Truland, and the Truland Foundation, this exhibition and catalogue would not have been possible.

Dr. Michael A. Brand
Director

ACKNOWLEDGEMENTS

The concept for this exhibition has evolved over the course of more than a decade, and has involved the efforts of a great many individuals. Foremost among them, I wish to thank Julie Boyd, former Director of the Institute for Contemporary Art at the Virginia Museum of Fine Arts, who in 1982 first exhibited Martin Puryear's work at the Museum in a group exhibition titled *American Abstraction Now.* Her invitation to Puryear in the late 1980s for a one-person exhibition provided the foundation for subsequent efforts. In 1993, Martin Friedman, Director Emeritus of the Walker Art Center and at the time consulting curator to the Virginia Museum of Fine Arts, brought Puryear to the Museum to consider a possible commission for the first reinstallation of the Sydney and Frances Lewis Galleries. While Puryear was unable to undertake either the exhibition or the commission, toward the end of the 1990s the opportunity to organize an exhibition of his work was finally realized. To Julie Boyd and Martin Friedman, for their foresight and inspiration, I am most grateful.

The collective efforts of many other individuals throughout the Museum have contributed to the realization of this exhibition and catalogue. I am grateful to Katharine Lee, former Director, for her commitment to this project, and to Dr. Michael Brand, current Director, for his keen support. I thank Carol Amato, Chief Operating Officer, and Richard Woodward, Senior Associate Director, for their key roles in the realization of this project. Special thanks are due to John Ravenal, Curator of Modern and Contemporary Art, for a rewarding dialogue throughout the development of this exhibition, and to Carol Moon, Manager of Exhibitions, for organizing and overseeing the implementation of the exhibition in Richmond. I am indebted to Rosalie West, editor of this catalogue, for her patience and expertise as the text developed. I also appreciate the assistance of editors Anne Adkins and Jenifer Buckman.

I am truly grateful to Jennie Runnels, Assistant Registrar, for her expertise, dedication, and efficiency in organizing the crating and transport of Puryear's sculptures for the exhibition in Richmond and the national tour. She deftly maneuvered through numerous challenges, ensuring that each doorway, elevator, and gallery entrance at the participating venues would accommodate these large sculptures. Her diligence, together with that of Katy Untch, Objects Conservator, in overseeing the transportation and installation of these objects throughout the tour is greatly appreciated.

The creative efforts of numerous Museum staff members have enriched this presentation of Martin Puryear's work. I am especially indebted to Sarah Lavicka, designer of the catalogue, for making this publication a work of art in itself; to Katherine Wetzel for her inspired photography of Puryear's most recent sculptures; to David Noyes, as always, for his outstanding exhibition design; and to Mary Brogan, for her skillful lighting design.

In fundraising, the efforts of Pete Wagner, Sharon Casale, and Elizabeth Lowsley-Williams have been invaluable, and have made the implementation of this exhibition possible. Dr. Suzanne Freeman and Rebecca Dobyns in the Museum's library have been exceptionally diligent and helpful in providing research materials. Connie Morris, Curatorial Secretary, deserves special praise for undertaking so many difficult but essential tasks, effortlessly and in good cheer.

In addition, many individuals have made important contributions to this effort: in the Director's Office, Candy Banks; in Collections, Caryl Burtner; in Community Affairs, Carolyn Adams; in Photography, Denise Lewis and Susie Rock; in Communications and Marketing, Michael Smith and Sara Johnson-Ward; in Public Affairs, Suzanne Hall, Don Dale, Allison Reid, and Mindy Campbell; in Publications,

Jean Kane, Lisa Hummel, and Michelle Wilson; in Exhibition Graphic Design, Michelle Edmonds, Kathy DeHaven-James, Beth Crisman, and Kennah Harcum; and in Lighting Design, Martha Pittinger and Robin Jones. In Registration, Frank Milik, Andy Kovak, Roy Thompson, and Randy Wilkinson deserve recognition for installing Puryear's work with such care. Special thanks go to Jim Heitchue in Objects Conservation for assisting Katherine Wetzel during two photography shoots in Puryear's studio, and to interns Kim Baranowski and HL Whitney for assembling preliminary research materials.

For their enthusiastic support of this exhibition and their participation in the national tour, I would like to express my gratitude to Peter Boswell, Senior Curator of Exhibitions and Programs at the Miami Art Museum; Constance Lewallen, Senior Curator at the University of California Berkeley Art Museum and Pacific Film Archive; and Trevor Fairbrother, Deputy Director for Art and the Jon and Mary Shirley Curator of Modern Art, and Chiyo Ishikawa, Senior Curator and Curator of European Painting at the Seattle Art Museum.

Commissioning photographic details of Puryear's sculptures involved the special efforts and talents of numerous individuals. I greatly appreciate the assistance of the following people for accommodating my requests within the strictures of already busy photography schedules: Sylvia Inwood at The Detroit Institute of Arts; Stacey Sherman at The Nelson-Atkins Museum of Art; Patricia Woods at The Saint Louis Art Museum; Bonnie Cullen at the Seattle Art Museum; Pat Kron at the Cleveland Museum of Art; and Kathleen Gillikin at The Baltimore Museum of Art. In addition to Katherine Wetzel, the photographers who have created stunning details of Puryear's work include Paul Macapia, Dirk Bakker, David Ulmer, and Robert Newcombe. Thanks are also due to Michael Tropea,

David M. Parker, Eduardo Calderon, and Bob Kolbrener for their photography of Puryear's work. For assistance with rights and reproductions I also thank Mary Anne Niebyl at the Des Moines Art Center, Jacklyn Burns at the J. Paul Getty Museum, and Howell Perkins at the Virginia Museum of Fine Arts. I would like in particular to thank Michael Puryear for his kindness in making the extra effort to obtain Sarah Wells' photographs for the catalogue.

Donald Young, David McKee, and especially Renee McKee provided invaluable assistance throughout all stages of developing this exhibition. Meg Larned and Kendra Schweitzer at the McKee Gallery in New York; and Jennifer Lange, Maureen Pskowski, and Emily Letourneau at the Donald Young Gallery in Chicago; facilitated a myriad of requests from research materials to photographs. Thanks go to Margo Leavin, Liz Alderman, and Ariana Johnson at the Margo Leavin Gallery in Los Angeles for their assistance as well.

I am especially grateful to the individuals and institutions that generously agreed to lend their treasured Puryear sculptures for this exhibition tour. For their unflagging assistance in realizing these loans I am especially thankful to the following curators: Dr. Cornelia Homberg and Dr. Rochelle Steiner at The Saint Louis Art Museum; Helen Molesworth at The Baltimore Museum of Art; Deborah Emont Scott at The Nelson-Atkins Museum of Art; Mary Ann Wilkinson at The Detroit Institute of Arts; Chiyo Ishikawa and Trevor Fairbrother at the Seattle Art Museum; Tom Henson at the Cleveland Museum of Art; Kirk Varnedoe, Cora Rosavear, and Robert Storr at The Museum of Modern Art, New York; and Arabella Ogilvie-Makari, Curator of the Agnes Gund Collection.

For ongoing support, inspiration, and counsel throughout the development of this project, I thank art historians Dr. Kevin Concannon and Dr. Robert Hobbs.

I am greatly indebted to Jeanne Englert and her predecessor, Melissa Moreton, assistants to Martin Puryear, for providing so much help as the project evolved.

My profound gratitude goes to Robert Truland for his extraordinary generosity, and to the National Endowment for the Arts for their support in making this exhibition and catalogue possible.

Finally, my deepest gratitude goes to Martin Puryear, an artist of exceptional integrity whose extraordinary work serves as an inspiration to us all.

Margo A. Crutchfield
Associate Curator of Modern
and Contemporary Art

SPONSORS

The Truland Foundation

The National Endowment for the Arts

LENDERS TO
THE EXHIBITION

The Baltimore Museum of Art

The Edward R. Broida Trust

The Detroit Institute of Arts

Agnes Gund and Daniel Shapiro

The Nelson-Atkins Museum of Art

Martin Puryear

Private Collection, New York

The Saint Louis Art Museum

Seattle Art Museum

Virginia Museum of Fine Arts

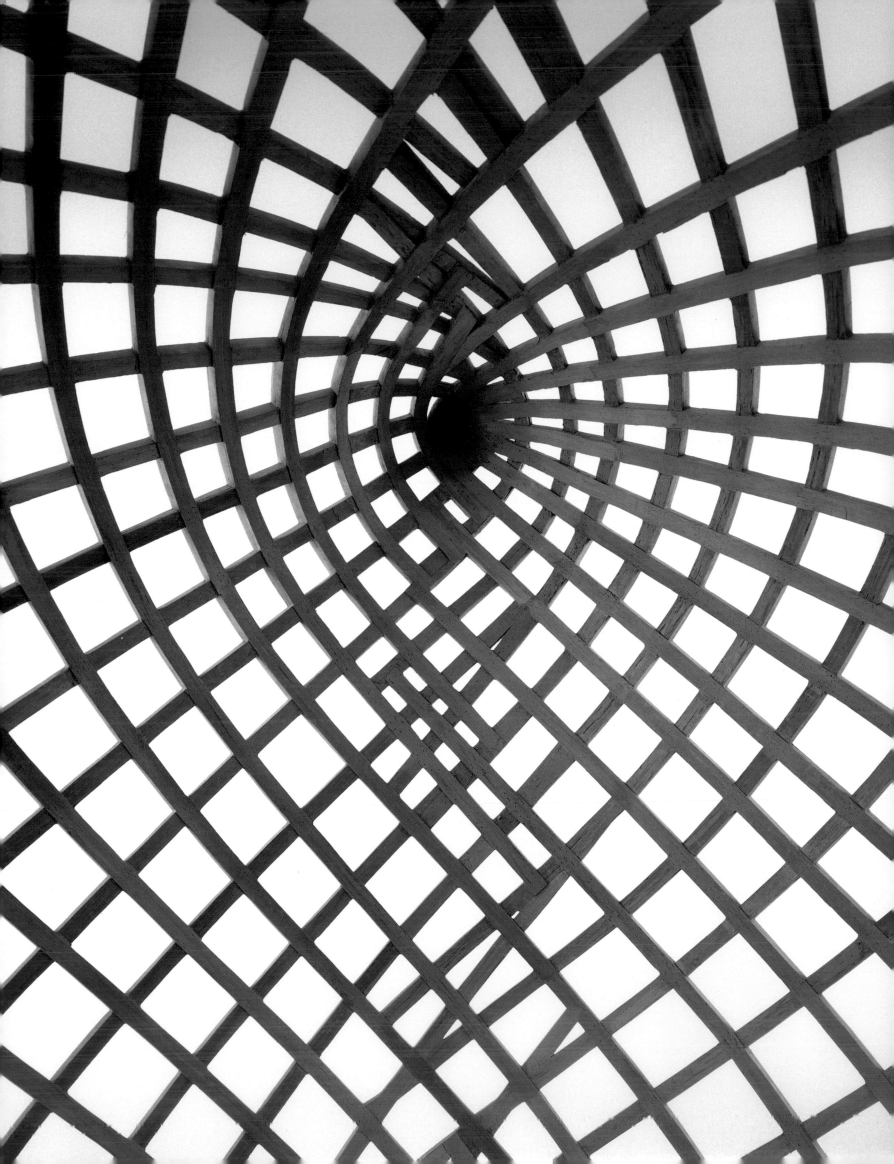

To encounter Martin Puryear's sculptures is to experience a world of powerful yet richly ambiguous objects. Distinguished by their inventive form and consummate craftsmanship, Puryear's sculptures have a engaging physicality. In his hands, materials such as wood, wire mesh, and tar attain a palpable, almost living presence. Predominantly abstract, Puryear's deceptively simple-looking sculptures trigger an array of associations that metamorphose in our minds as we contemplate their archetypal forms. *Lever #3,* 1989 (fig. 1), for example, made of painted Ponderosa pine, might suggest either a plant extending an elongated tendril or an animal gracefully stretching its neck. In either case, its elegant contours conjure a fluid form, at once beautiful and alive. *Old Mole,* 1985 (fig. 2), made of woven strips of red cedar, alludes not only to the burrowing animal of its title but to other possibilities as well. Its enigmatic shape might suggest the head of a person, a bird, or—from another angle—a ship's prow. A muffled, blinded, or mummified head might also come to mind.

Fig. 1
LEVER #3, 1989
Painted Ponderosa pine
84 ½ x 162 x 13 in. (214.5 x 48.2 x 33.0 cm)
National Gallery of Art, Washington, D.C.
Gift of the Collector's Committee, 1989.71.1

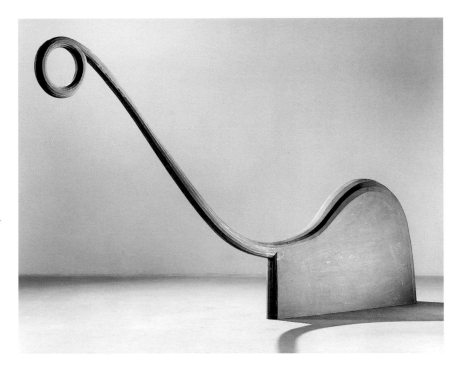

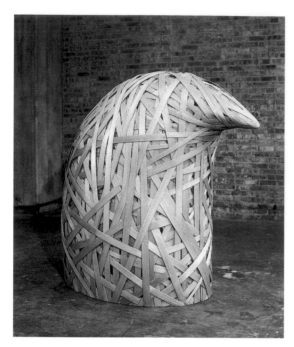

Fig. 2
OLD MOLE, 1985
Red cedar
61 x 61 x 32 in. (154.8 x 154.8 x 81.2 cm)
Philadelphia Museum of Art
Purchased: The Samuel S. White, 3rd, and Vera White
Collection (by exchange) and Gift of Mr. and Mrs. C. G.
Chaplin (by exchange) and funds contributed by Marion
Stroud Swingle, and funds contributed by friends and
family in memory of Mrs. H. Gates Lloyd.

But while Puryear's sculptures make reference to recognizable forms, they elude specific definition, engaging the viewer in an imaginative analysis that is no less rewarding for its ultimate failure to yield any definite interpretation. Puryear's abstract forms are "vaguely familiar but unknown,"[1] and true to the modernist tradition out of which they emerge, they seem to exist outside time and place.

Since the mid-1970s Puryear has created an outstanding body of sculpture that builds on the tradition of organic abstraction established by artists such as Constantin Brancusi and Jean Arp earlier in the twentieth century. Carrying this tradition forward, Puryear incorporates a minimalist simplicity of form and an emphasis on process and materials that aligns him with postminimalist sculptors. To this heritage Puryear adds a devotion to craftsmanship and the handmade as a means to achieve his artistic vision. His wide-ranging knowledge of nature and wildlife, history, and geography, and his fascination with Native American, African, Scandinavian, Japanese, and arctic cultures, have informed and enriched his visual vocabulary. Puryear transforms and distills a diversity of sources in his abstract sculptures and pares them down to the essential,[2] resulting in a body of elemental forms remarkable for their unusual beauty and metaphoric resonance (fig. 3).

As an artist, Martin Puryear resists categorization: initially a painter, he became a sculptor; originally a figurative artist, he later turned to abstraction. He draws on multiple cultural and artistic sources, yet is not defined by any of them. His work is equally difficult to categorize. It hovers between abstraction and figuration. It is made with wood, a traditional material, but also with the highly unconventional combination of wire mesh and tar. And while his sculpture comes out of the postminimalist tradition, and shares affinities with the work of artists ranging from Jackie Winsor to the British sculptor Richard

Deacon, Puryear has always stood apart, outside the prevailing trends in the contemporary art world. In the 1980s, when Neo-Expressionism and the aesthetics of appropriation swept the art scene, Puryear remained steadfast with his reductive, universal forms. In the 1990s, when many African American artists overtly engaged social issues and the politics of identity in their art, Puryear created work that was more subtle. While a number of his sculptures specifically reference his African American heritage, Puryear's work for the most part transcends the specific for more universal concerns. Amidst the continually shifting postmodernist landscape, Puryear has maintained a constant and singular vision: unafraid of beauty, the well-made object, and the viability of meaning in art and in our world, he is without question one of America's pre-eminent sculptors.

Puryear's working methods are uncommon in contemporary art practice as well, a result perhaps of his complex and varied training. He first studied painting at Catholic University in Washington, D.C., followed by graduate work in sculpture at Yale University. He also observed and learned from the carpentry and woodworking techniques of artisans in Sierra Leone, where he served as a Peace Corps volunteer from 1964 to 1966, and furniture makers in Sweden, where he lived from 1966 to 1968. Although Puryear has commented that this period has received an exaggerated amount of critical attention and has consequently become "the myth behind the work,"[3] his experience in these countries solidified his interest in craft traditions and his commitment to mastering techniques and materials. "In more traditional, more slowly evolving societies you spend time learning from an acknowledged authority, and you only earn the right to be an artist, with anything personal to invest in the work, through mastery."[4] In Sweden, Puryear studied printmaking at the Swedish Royal Academy of Art while making sculpture in the evenings and pursuing

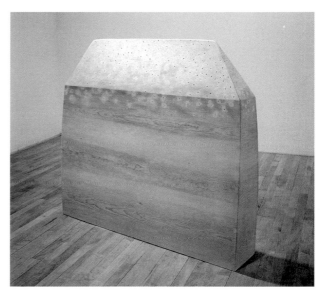

Fig. 3
RELIQUARY, 1980
Gessoed pine
42 x 47 1/2 x 9 in. (106.6 x 120.6 x 22.8 cm)
Collection of Gayle and Andrew Camden, Detroit, Michigan

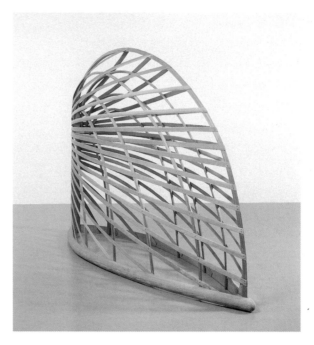

Fig. 5
BOWER, 1980
Sitka spruce and pine
64 x 94 3/4 x 26 5/8 in. (162.4 x 140.5 x 67.6 cm)
Collection of Camille Oliver-Hoffmann, Chicago, Illinois

Fig. 4
KEEPER, 1984
Pine and steel wire
100 x 34 x 38 in. (253.8 x 86.3 x 96.4 cm)
Collection of Alan and Wendy Hart, Topanga, California

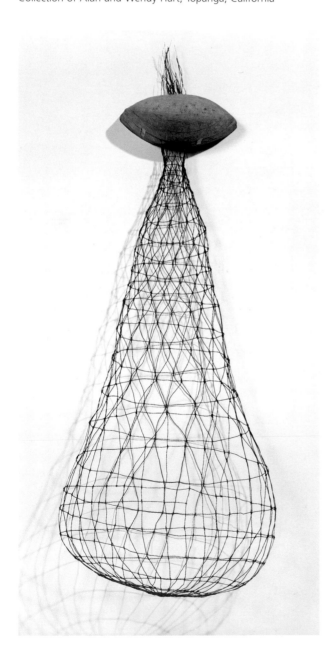

his interests in Scandinavian design and furniture making.[5] Puryear's fascination with basketry, quill-work, and other arctic crafts (fig. 4) was furthered in this period, during which he traveled in Lapland.

Building on these influences, Puryear developed an approach to making sculpture based in traditional craft techniques. Rather than carving or casting, his primary interest is in building, constructing, and assembling—using accumulative processes such as wrapping, tying, and weaving, or lamination and joinery techniques traditionally associated with furniture making and shipbuilding (fig. 5). These labor-intensive methods have become the basis of Puryear's signature style and technique. "The process of making has always been central to every-thing I've done," [6] Puryear has said. " . . . I enjoy and need to work with my hands, with tools . . .

they give you a measure of the extensions of the mind and body . . . they keep ideas of the work connected to the man making them."[7]

Puryear works primarily with wood, and few if any artists today can approach his virtuosity in this medium.[8] His extraordinary manipulation of wood and his keen understanding of its aesthetic possibilities have resulted in finely crafted sculptures in a surprising range of forms. Puryear can transform poplar, spruce, mahogany, oak, hickory, cypress, vine, or rattan—to name only a few of the many types of wood he employs—into monoliths, sculptures in the shape of rings, linear wall pieces (fig. 6), small pedestal works, or monumental sculptures.

Puryear is also adept with wire mesh coated with tar, a material that he chose in part for its strong but pliable qualities and its ability to be transformed by bending, binding, or stretching.[9] This unorthodox combination of materials gives "the impression of

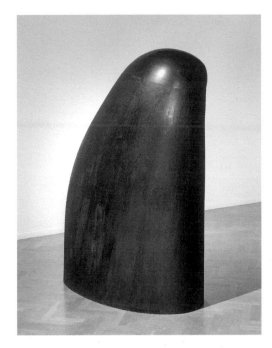

Fig. 7
SELF, 1978
Painted cedar and mahogany
69 x 48 x 25 in. (175.1 x 121.8 x 63.5 cm)
Joslyn Art Museum, Omaha, Nebraska
Purchase in memory of Elinor Ashton

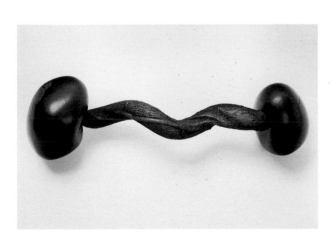

Fig. 6
UNTITLED, 1978
African blackwood and vine
15 7/8 in. long (40.3 cm)
Collection of Mr. and Mrs. Robert W. Truland

heavy volumes and solids, but once approached, one sees that it is transparent. It becomes light. I like the notion of solidity and transparency at the same time."[10] Puryear exploits these properties to maximum effect: "I'm interested in mediating between a feeling of massiveness and fragility to reach a point of extreme vulnerability. Wire mesh allows for all of this."[11]

Puryear's use of laminated cedar and mahogany achieves similar results. *Self,* 1978 (fig.7)—"a visual notion of the self"[12] as he describes the piece—appears solid and massive like a block of marble, but it is built of thin layers of cedar, and is in fact hollow and lightweight. These dualities—solid/hollow, massive/lightweight—and others such as interior/exterior, linear/volumetric, and representational/abstract, resonate throughout Puryear's sculpture.

Puryear's current body of work is rooted in the late 1980s, during which time he created two highly inventive series: *Stereotypes and Decoys,* 1987, a group of birdlike forms reminiscent of duck-hunting decoys, and the *Lever Series* of 1988–89, which includes *Lever #2,* 1989 (cat. no. 1), a graceful twenty-four-foot-long work of unpainted Ponderosa pine, ash, cypress, and rattan. This sculpture and the woven rattan tower, *Charm of Subsistence,* 1989 (cat. no. 2), were among the works Puryear exhibited at the 1989 São Paulo Bienal in Brazil, for which he was awarded the prestigious grand prize. In 1989 Puryear was also honored with a MacArthur Foundation Fellowship. This was a time of transition for Puryear. As his work began to receive increasingly widespread national and

international acclaim, he was able to stop teaching and devote himself full time to his art. In 1990 Puryear left Chicago, his home since 1978, and moved to upstate New York, where he built a new house and studio in collaboration with the Chicago architect John Vinci.

This exhibition begins with two works from 1989 and focuses on a selection of works from the 1990s through the end of 2000, including recently completed sculptures from the artist's studio. In this span of eleven years, Puryear produced an ambitious body of work, including individual sculptures, temporary installations, and a number of public commissions that constitute an important aspect of his oeuvre (fig. 8).[13] Most of Puryear's individual

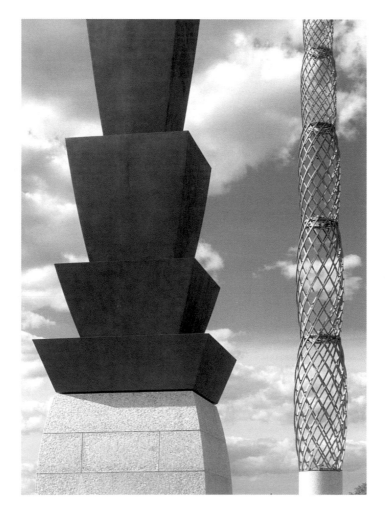

Fig. 8
NORTH COVE PYLONS, 1992–95
Battery Park City, New York, on the Hudson River opposite the Statue of Liberty
Granite and stainless steel
North Pylon: 72.3 x 5.8 ft. (22.04 x 1.77 m)
South Pylon: 57 x 7 x 7 ft. (17.37 x 2.13 x 2.13 m)

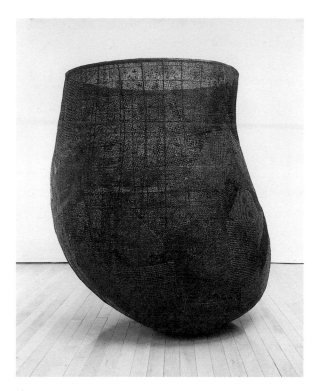

Fig. 9
NO TITLE, 1993–95
Wire mesh, tar, tree stump, anvil, and wood
81 x 75 x 64 in. (205.6 x 190.4 x 162.4 cm)
Tokyo International Forum, Tokyo, Japan

works of this period are marked by increasing assertiveness, scale, and volume. They range from the extended *Lever #2* to the more compact and muscular *Thicket,* 1990 (cat. no. 3), a sturdy structure of coarse intersecting beams, to large, organically shaped sculptures with smooth surfaces such as *Plenty's Boast*, 1994–95 (cat. no. 5), or the elegant untitled cedar monolith of 1997 (cat. no. 8).

During the course of the 1990s, the wire mesh sculptures figured prominently and became more versatile. They assumed the tall elegant proportions of the gourdlike *Untitled,* 1995 (cat. no. 6), became a giant vessel in *No Title,* 1993–95 (fig. 9), or took the form of a circle in *Untitled,* 1997 (cat. no. 9). During this time, Puryear also created a number of small pedestal pieces in both bronze and wood and

began to explore new materials. He used copper for the first time in a dome-shaped monolith in 1997,[14] and glass in the exhibition's latest work, *Horsefly,* 1996–2000 (cat. no. 11).

Puryear's most recent sculptures are monumental. Their sheer size and presence are striking. Foremost among them is *Brunhilde,* 1998–2000 (cat. no. 12), a latticed work made of laminated strips of red cedar that rises to a height of eight feet and extends to a width of nine feet across the top and a depth of six feet. Puryear's use of scale takes dramatic form in *Ladder for Booker T. Washington,* 1996 (cat. no. 7), a thirty-six-foot-high suspended ladder made of ash whose width decreases incrementally with height so that it appears to vanish into the distance. Scale and especially volume are dominating, almost daunting factors in *Horsefly* (cat. no. 11) and *Confessional* (cat. no. 10), both from 1996–2000. The former, spiraling upwards from a bulbous mesh base into a blackened curvilinear form, appears strangely buoyant, like a mythical chariot or a vessel about to embark. The massive *Confessional,* on the other hand, is more grounded. Hinting at a shelter or hut, an enormous head, or a tomb, this dark and imposing mesh form confronts us with its raw and powerful presence.

In Puryear's art meaning and significance are intentionally ambiguous, leaving it wide open to interpretation. Many of the allusions in his works— to organic or animal forms and to an array of manmade objects such as vessels, huts, nets, hunting implements, and tools—become metaphors for universal ideas and fundamental human concerns. Vessels (e.g. figs. 9 and 10), containers, or shelters[15] hold or enclose space, suggesting protection, survival, fullness or emptiness, sanctuary, or captivity. References to hunting implements and tools[16] allude to man's relationship to nature and human efforts to reap its resources. Images of tools

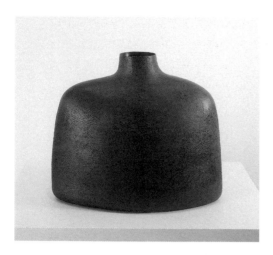

Fig. 10
UNTITLED, 1994
Bronze
15 x 16 x 5 ½ in. (38.1 x 40.6 x 14.0 cm)
Artist's proof, edition of 2
Collection of the artist
Courtesy of McKee Gallery, New York

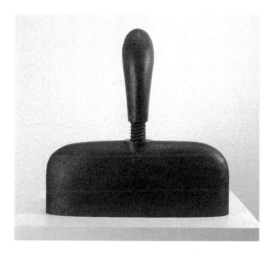

Fig. 11
UNTITLED, 1994
Bronze
21 ½ x 21 x 4 ¼ in. (54.6 x 53.3 x 10.8 cm)
Cast 1, edition of 2
Courtesy of McKee Gallery, New York

(e.g. fig. 11) also invoke the idea of labor, the ability to build or create by hand, and the value of such endeavors. The monolith or primeval head speaks to human efforts to represent some semblance of the self, and to mark and leave evidence of our existence (fig. 12).

It would seem that recurring references in Puryear's work to biological or botanical forms convey a fascination with nature and its timeless processes of growth and change.[17] Themes of metamorphosis and transformation, in nature and in the human spirit, are subtly infused throughout Puryear's oeuvre. Images of birds (e.g. fig. 13) and boats[18] imply movement and change, the idea of discovery, of journeys, of seeking the beyond. Birds also suggest a transcendent spiritualism: in cultures around the world, birds symbolize the human soul[19] and serve as messengers between terrestrial and celestial realms. Likewise, ladders represent a nexus of the earth and sky, heaven and earth, and suggest spiritual ascension.[20] Symbolically charged, Puryear's sculptures engage us on sensual, emotional, and intellectual levels. In his work, as one art critic has observed, "one perceives a sense of wholeness, a sense of primal connection to all living things."[21]

In many of Puryear's works, wire mesh or laminated strips of wood cover the framework to give form to the volume within. These surfaces are membranes—in Puryear's words "a continuous skin"—that delineate space. Puryear describes his works in both universal and formal terms. "They have a vessel quality," he remarks, "they enclose space at various scales."[22] This interior space is guarded by a foreboding tangle of intersecting beams in *Thicket*, 1990 (cat. no. 3), and becomes impenetrable in the dark contoured form of *Untitled*, 1997 (cat. no. 8); in *Brunhilde*, 1998–2000 (cat. no. 12), it is contained yet open and filled with energy generated by shifting patterns of refracted light and shadow.

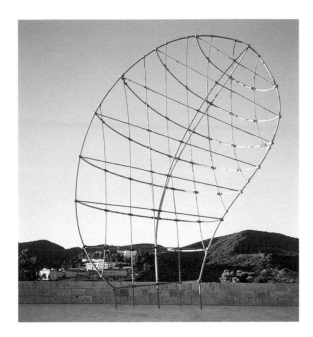

Fig. 12
THAT PROFILE, 1997–99
Stainless steel and bronze
45 x 30 x 11.3 ft. (13.72 x 9.14 x 3.48 m)
A commission by the J. Paul Getty Trust, for the Getty Center
Tram Arrival Plaza, Los Angeles, California

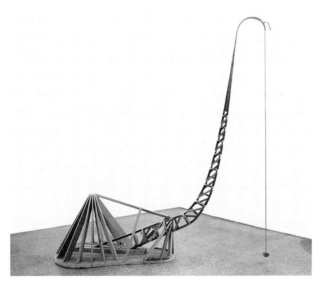

Fig. 13
UNTITLED, 1997
Pine, cypress, ash, and rope
143 1/2 x 132 x 44 in. (364.2 x 335.0 x 111.7 cm)
Collection of the artist

In the wire mesh sculptures, the interior is veiled; the surface is opaque from a distance, but translucent at close view, as if it were protecting or concealing a mysterious core while simultaneously seeking to reveal it.

This dialogue between interior and exterior, and the dichotomies between open and closed, visible and invisible, protected and exposed, are at the core of much of Puryear's art and continue in the work of the 1990s. In sculptures such as *Confessional,* 1996–2000 (cat. no.10), the perforated surface is at once solid and porous, impenetrable but partially accessible. With the kneeling stool placed in front of its colossal head, *Confessional* would seem to encourage self-disclosure and, like much of Puryear's work, offers not a declaration but an invitation.

Brunhilde, 1998–2000 (cat. no. 12), also suggests a dialogue between interior and exterior. In this magnificent structure, a bulging, animated interior is constrained by an elegant web of intersecting cedar strips. Puryear wanted to create a work that seemed to be "straining at the skin," to have "an internal expansion, as though it were inflated, filled with something, like a filled bag, or a balloon, or an airship—like things that are inflated and are pushed from within."[23] One senses an unseen force pushing against the enclosing membrane, a barely bound energy on the verge of ascension, perpetually at the point of breaking free.

Whether Puryear's sculptures signal freedom and escape, sanctuary, or a forbidden and captive space, whether they reveal or conceal, they are richly evocative and complex. Puryear's work is filled with the possibility of meaning; his sculptures are not only objects of mysterious beauty but seductive sites of discovery and revelation.

M.C.

WORKS IN THE EXHIBITION

Height precedes width followed by depth.

LEVER #2, 1989

Ponderosa pine, ash, cypress, and rattan

71 x 293 x 55 in. (180.34 x 744.22 x 139.70 cm)

The Baltimore Museum of Art

The Caplan Family Contemporary Art Fund

and Collectors Circle Fund

Cat. No. 1

In this graceful and expansive work, a fluted rattan frame joins a wooden extension that gently curves through the air and ends in a knob on the floor. Made of finely sanded Ponderosa pine, ash, cypress, and rattan, *Lever #2* is five feet tall at its greatest height and spans almost twenty-four and a half feet. Like many works by Puryear, this sculpture evokes the organic world of birds and plants: "a swan dipping its beak in the water"[24] or a sensual bell-shaped flower languidly reclining on the floor. However, its title suggests an association with tools, in this case, ironically, tools designed to capture wildlife: traps, fishing lines, lassos, or bolas.

Initially, Puryear thought of this piece as a reference to polygamy, with the single "stamen" connecting with or proliferating into the multiple strands of the frame.[25] The sculpture might also be perceived as an enormous child's toy, with the wooden knob bobbing across the floor. Fluctuating between the abstract and the representational, *Lever #2* seamlessly embodies contrasting notions: it is both playful and subtly menacing.

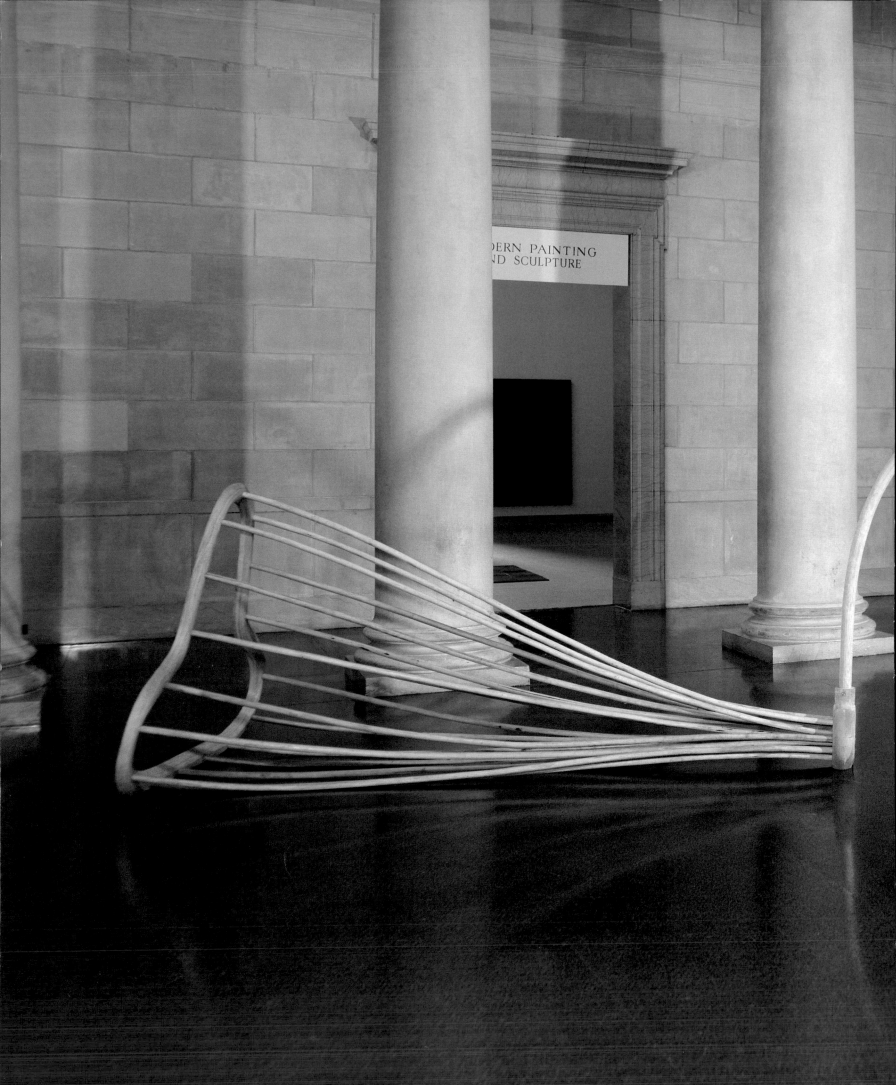

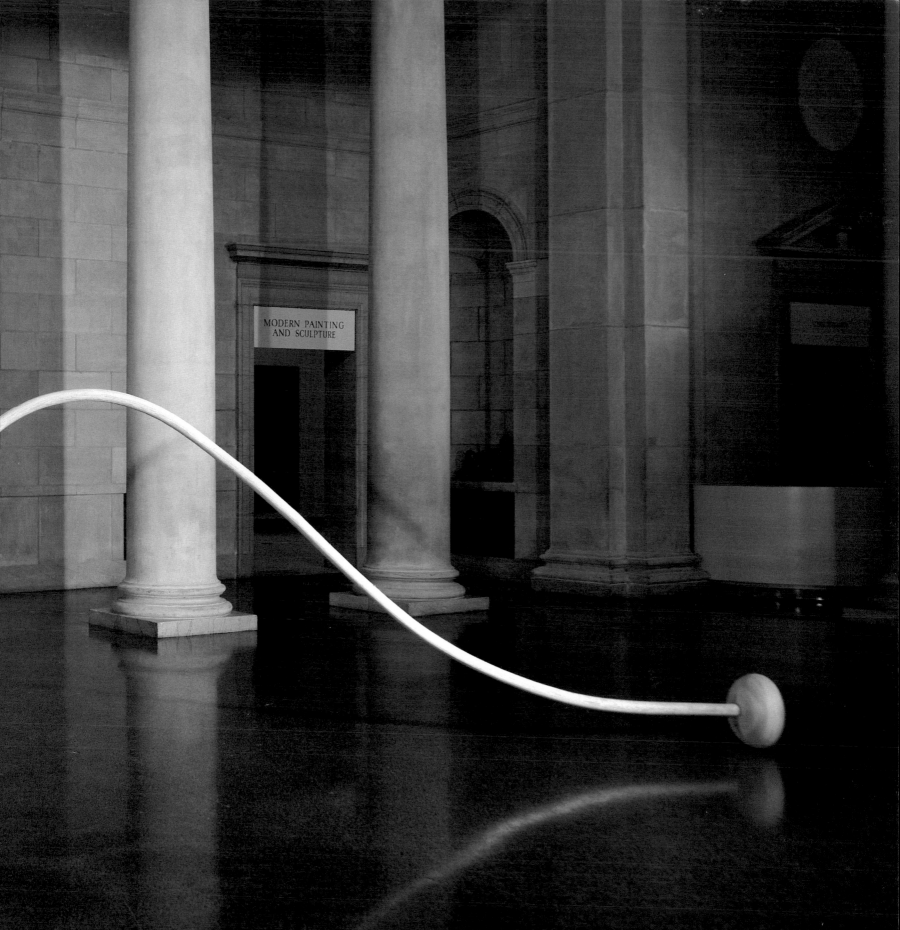

CHARM OF SUBSISTENCE, 1989

Rattan and gumwood

85 x 66 x 9 in. (215.90 x 167.64 x 22.86 cm)

The Saint Louis Art Museum

Funds given by the Shoenberg Foundation, Inc.

Cat. No. 2

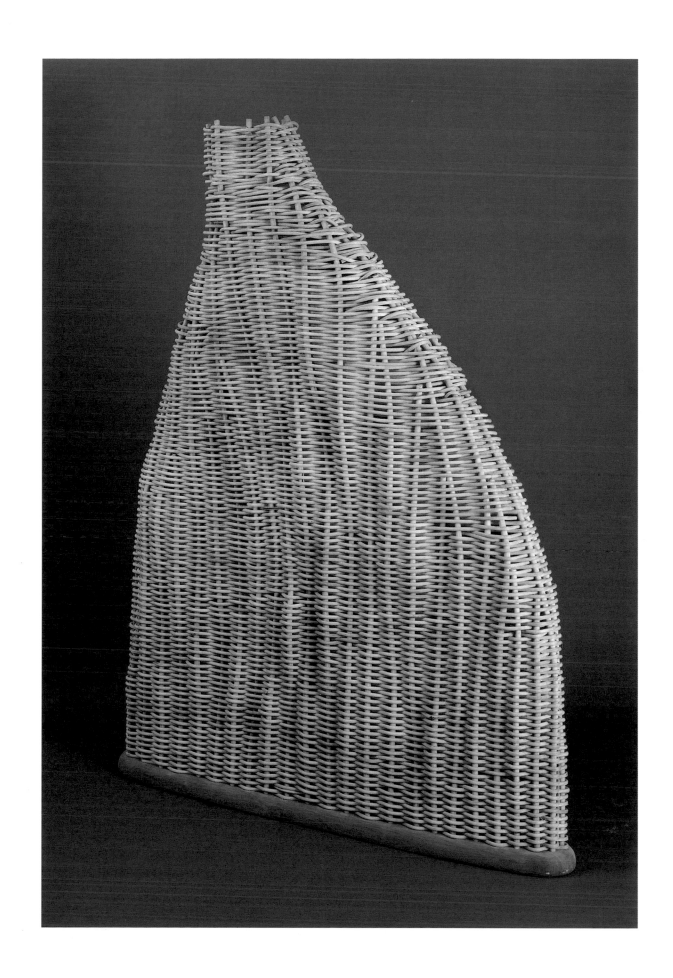

Charm of Subsistence reflects Puryear's fascination with basketry and his interest in what he describes as "incremental processes or methods of constructing that build slowly like a spider's web."[26] This tall, intriguing form is made with rods of rattan woven together like a basket. Its abstract shape seems modern, but with its blanched color and its rugged, irregular weave, the sculpture appears worn and aged, even ancient.

Nearly six feet wide but a mere seven inches deep, *Charm of Subsistence* appears dramatically transformed when viewed from different angles or perspectives. Yet despite its size, this woven, hollow sculpture is surprisingly lightweight,[27] and what seems to be a simple object is in fact complex.

Massive and lightweight, ancient and modern, simple and complex: *Charm of Subsistence* contains an engaging set of dualities. As the artist has stated, "the strongest work for me embodies contradiction, which allows for emotional tension and the ability to contain opposing ideas."[28]

THICKET, 1990

Basswood and cypress

67 x 62 x 17 in. (170.18 x 157.48 x 43.18 cm)

Seattle Art Museum

Gift of Agnes Gund

Cat. No. 3

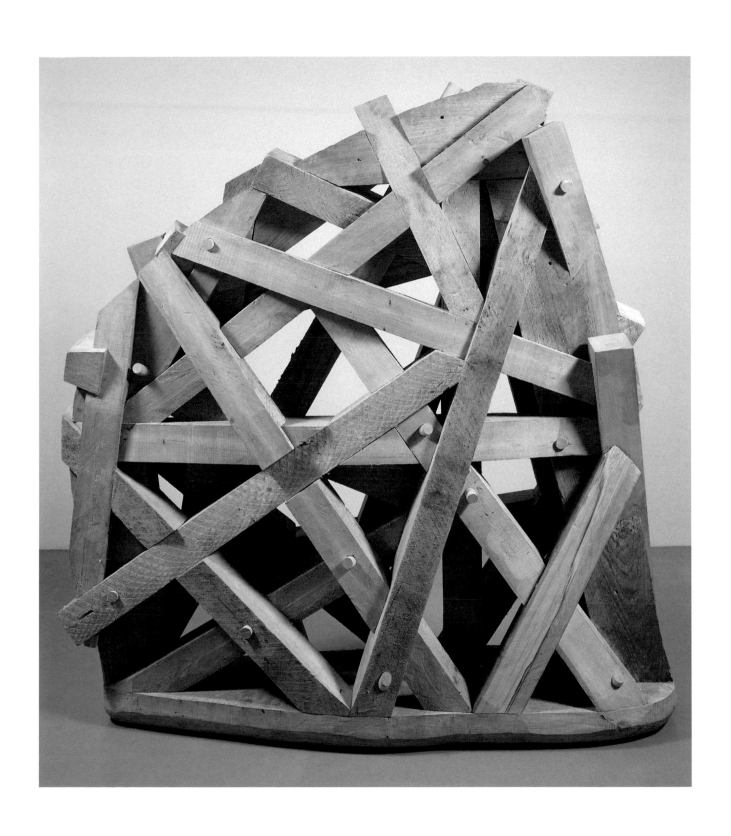

Puryear's fascination with nature takes concrete form in *Thicket,* the shape of which was inspired by a rock Puryear found on a trip into the Alaskan wilderness in 1980.[29] In this work, made of basswood and cypress, Puryear employs materials and techniques normally used in construction—for example, framing and pegged joinery[30]—to assemble, layer, and overlap thick lengths of wood into a sturdy three-dimensional mesh. As suggested by its title, *Thicket* is dense and almost impenetrable in some areas, but open with a visible interior in others.

Puryear has spoken about many of his sculptures as frameworks or "skeletons to be covered with a skin of wire mesh or wood."[31] In contrast, the structure of *Thicket* is open and uncovered: this piece "is all skeleton."[32] In his ongoing exploration of form, Puryear moves beyond the surface in *Thicket,* laying bare its essential structure to create an object that simultaneously lures the viewer to peer within while remaining inextricably barricaded.

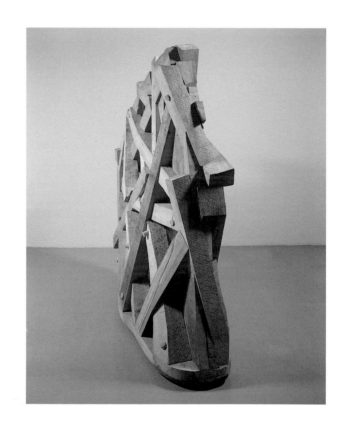

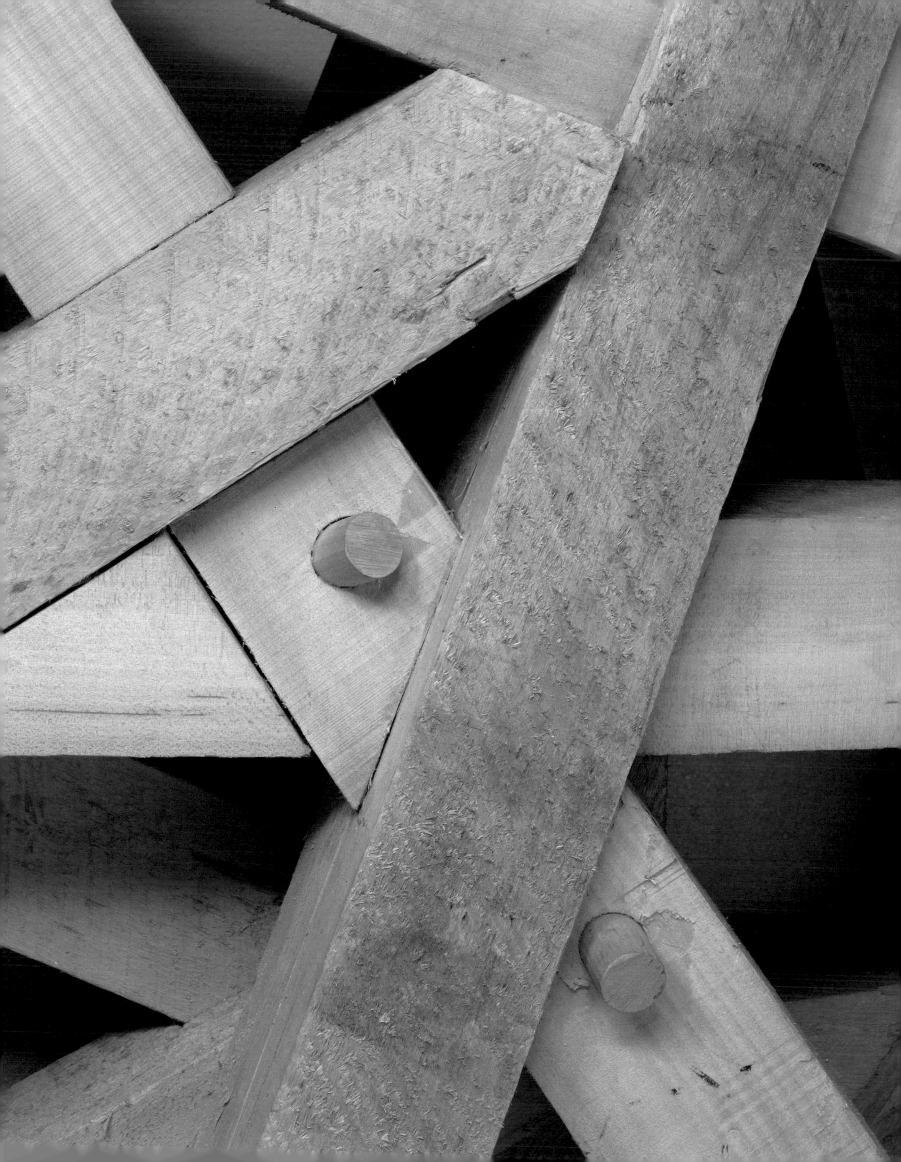

ALIEN HUDDLE, 1993–95

Red cedar and pine

53 x 64 x 53 in. (134.62 x 162.56 x 134.62 cm)

Private collection, New York

Cat. No. 4

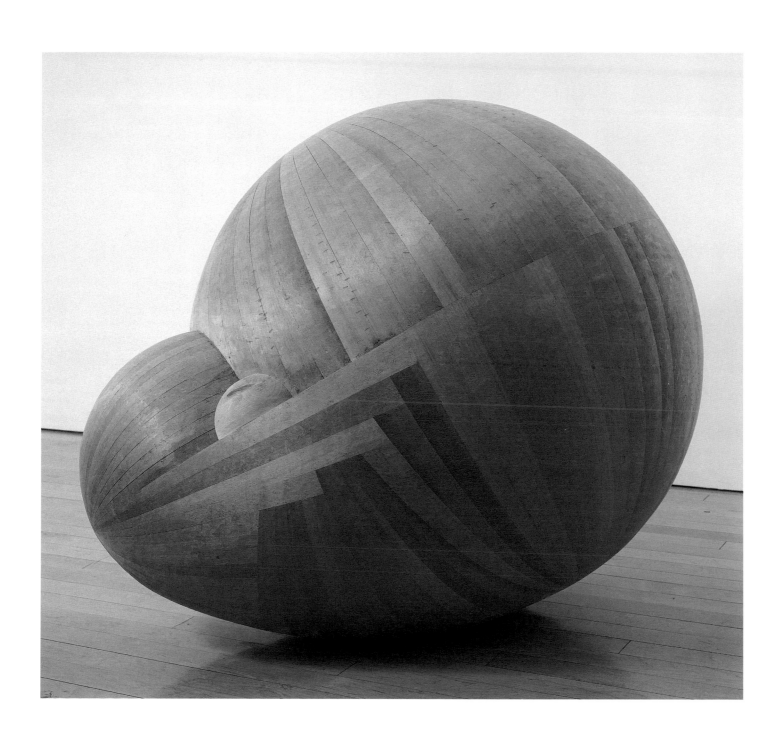

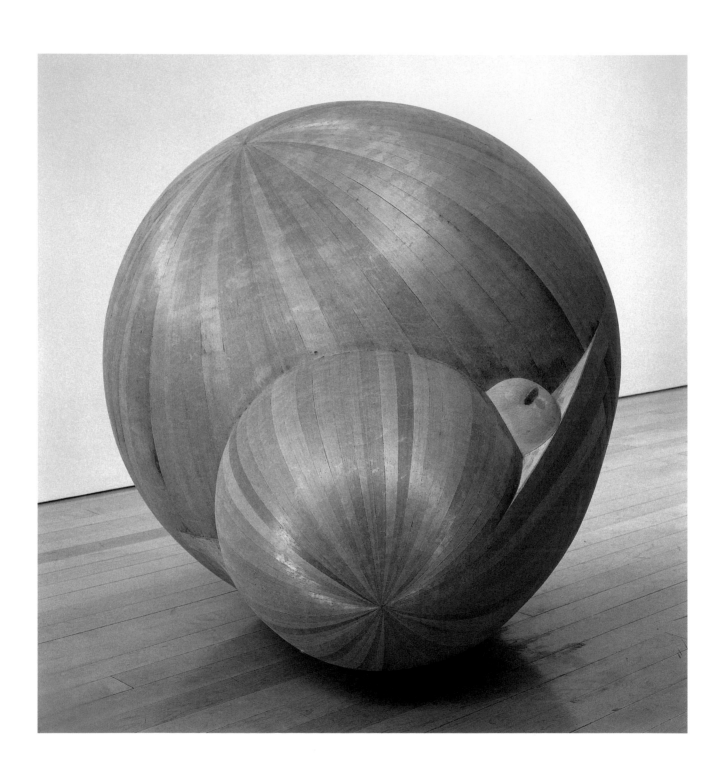

Alien Huddle is an example of the kind of form for which Puryear is well known: the exquisitely crafted, enigmatic object. Puryear began making *Alien Huddle* while he was artist-in-residence at the Calder Foundation in Saché, France, in 1993. He completed the sculpture two years later in his studio in upstate New York. Using a technique derived from boat building, Puryear laminated thin strips of red cedar over a framework to create three tightly intersecting spheres.[33] As is frequently the case in his work, Puryear's process and technique are revealed in the remnants of staple marks embedded in the sculpture's smooth, untreated wood surface.

Alien Huddle's resemblance to pods or dividing cells—which suggest fertility or regeneration—reflects Puryear's ongoing interest in organic form. With its fusion of large, medium, and small spheres, the work suggests a family group[34] nestled together, evoking themes of interdependence and protection. The sculpture can also be perceived as a cluster of globes or hemispheres; a group of alien life-forms, as its title suggests; or even "a ball of twine, its thin

alternating cedar . . . planks like strands of string."[35] For the artist, "where it started was with architecture, with clusters of domes, like in mosques."[36] Commanding in scale, this elemental form, though richly allusive, resists specific interpretation.

PLENTY'S BOAST, 1994–95

Red cedar and pine

68 x 83 x 118 in. (172.72 x 210.82 x 299.72 cm)

The Nelson-Atkins Museum of Art

Kansas City, Missouri

Purchase: The Renee C. Crowell Trust

Cat. No. 5

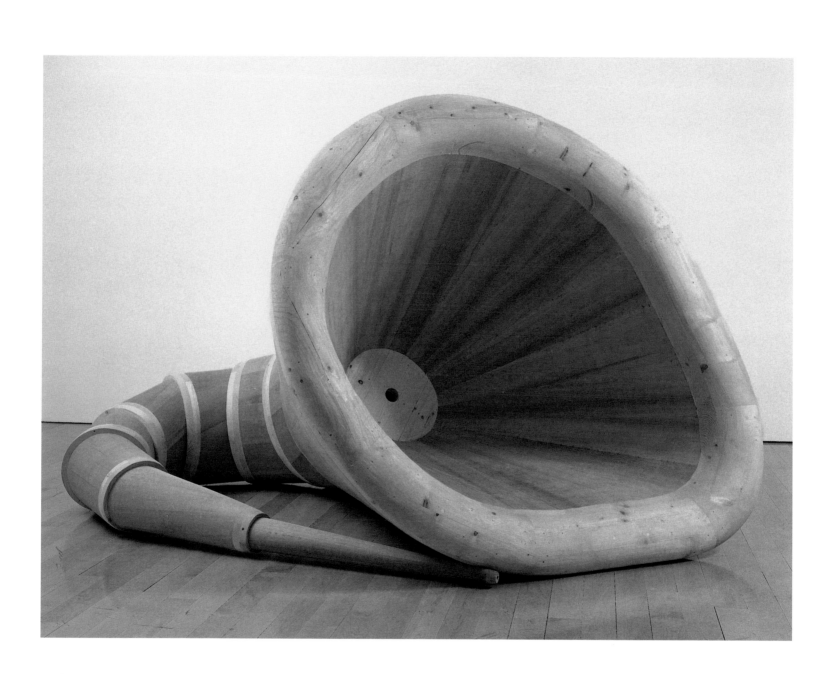

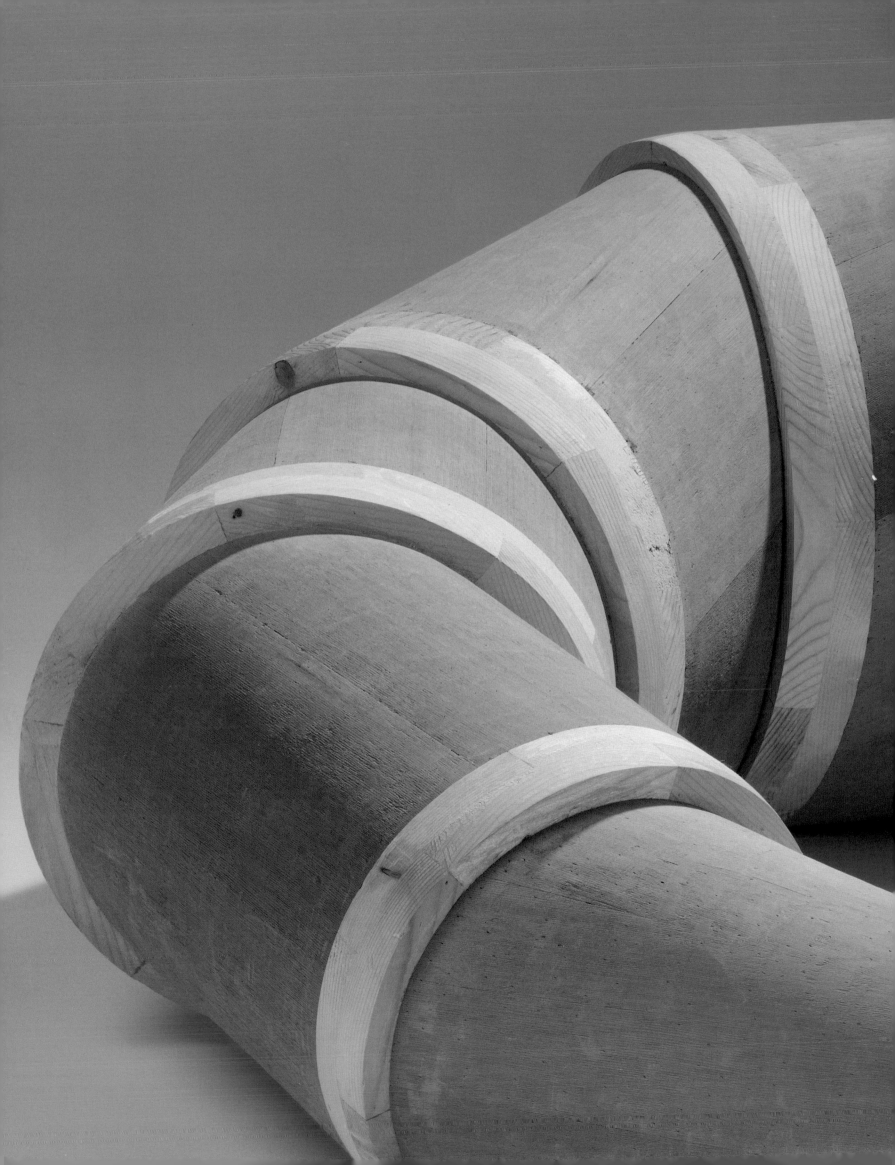

This hybrid, almost surreal object makes reference to the natural and the man-made, alluding to both animate and inanimate forms. Its open, flared end suggests a tuba, a cornucopia, a morning glory, or an old-fashioned phonograph horn.[37] It also suggests an animal with its long tail tucked around its body, or "a fantastic sea slug or anemone that could as easily ingest the passing viewer as spill out fruit and flowers."[38] The contradiction between bountiful nourishment and a potential threat, and the tension of simultaneous attraction and repulsion, add further complexity to the piece.

Other concepts such as contraction and expansion come into play here as well. Like *Ladder for Booker T. Washington* (cat. no. 7), this sculpture is dramatically larger at one end than the other. A gaping opening shrinks to a tiny black hole in the bowl of the sculpture. Conversely, the capped tip of the sculpture's "tail" surges into a giant, open cavity. The hole in the middle of the piece also demonstrates Puryear's ongoing interest in interior space.

Puryear constructed *Plenty's Boast* with boat-building techniques, wrapping, gluing, and stapling thin layers of cedar over a wooden armature. Traces of glue and staple marks on the surface are evidence of this laborious process. The work's sensual surface of smooth, untreated cedar and pine and its large, enveloping scale elicit a visceral response. This strange but vaguely familiar form is essentially ambiguous, but immediately engaging.

UNTITLED, 1995

Wire mesh, tar, cedar, and particle board

87 x 24 x 49 in. (220.98 x 60.96 x 124.46 cm)

Virginia Museum of Fine Arts

Museum Purchase: The Sydney and Frances Lewis

Endowment Fund

Cat. No. 6

Untitled, 1995, embodies the simplicity of form and evocative power characteristic of Puryear's work. Although not as readily apparent as in his wood sculptures, this piece results from a meticulous and time-consuming process. After bending and molding steel rods to create its framework, Puryear covered the form with squares of wire mesh that he tied together with thin pieces of wire. He then coated the wire mesh surface with a rich layer of tar.

Typical of Puryear's sculptures, this piece makes reference to recognizable forms but eludes definition. The sculpture's compelling, almost regal presence suggests a colossal head or some archetypal monolith. At the same time, it is organic in form, resembling a seedpod or gourd. From a distance, the sculpture appears solid; on closer view, the wire mesh becomes more transparent, hinting at the framework within. This opposition between the work's seemingly opaque exterior and its obscured but transparent interior, between what is concealed and what is revealed, reinforces its subtle but pervasive sense of mystery.

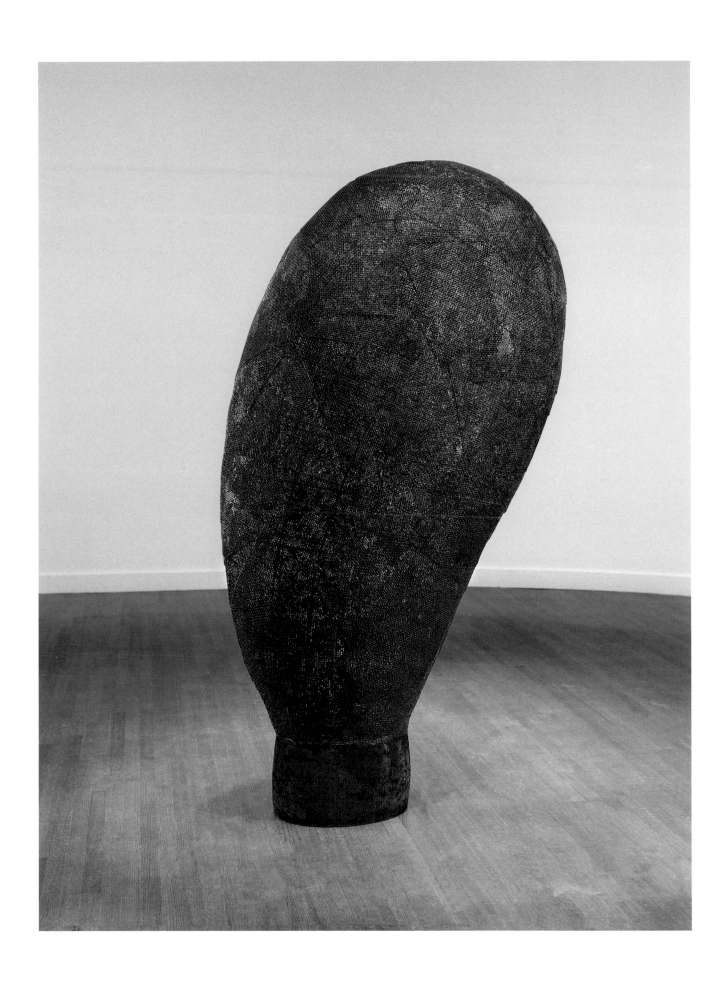

**LADDER FOR
BOOKER T. WASHINGTON,** 1996

Ash

438 x 22 ¾ x 1 ¼ in. (1112.52 x 57.79 x 3.18 cm)

Collection of the artist

Cat. No. 7

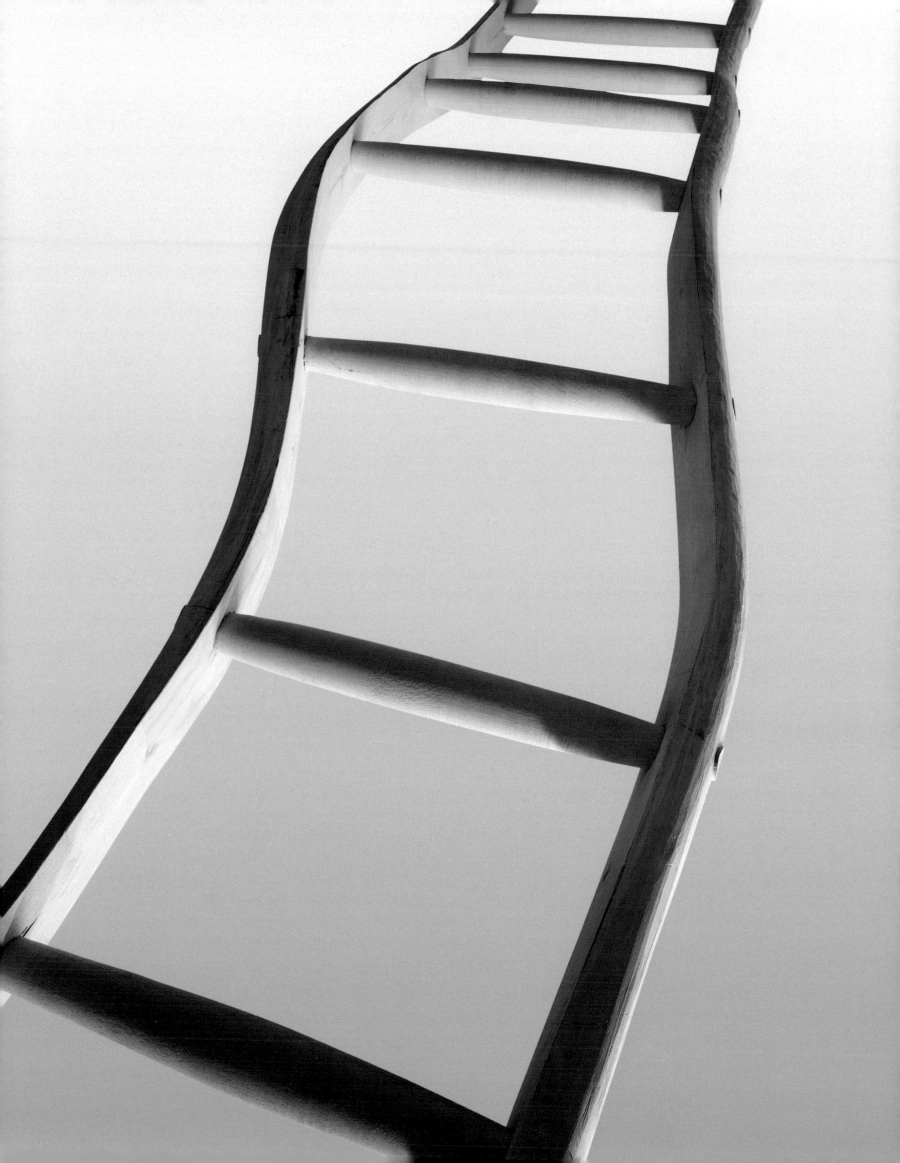

This remarkable thirty-six-foot ladder was made from an ash tree Puryear felled on land surrounding his home and studio in upstate New York. He split the tree into two continuous sections to form the sides. Each rung is a hand-turned dowel, carefully joined into place. The width of the ladder diminishes incrementally with height, each rung becoming successively shorter as the ladder gradually narrows from almost two feet at the base to just over an inch at the top.

Puryear's dedication to traditional woodworking techniques is evident here, as is his interest in formal concerns. As Puryear explained, "the issue of forced or exaggerated perspective and how it influences the perception of the work's actual size and position in space"[39] was a primary interest in this work.

Puryear has created a number of works that reference African American history. *For Beckwourth*, 1980, for example, pays homage to James Beckwourth (1798–1866), an African American scout and explorer whose place in standard histories has been overlooked. Puryear's 1996 ladder is titled after Booker T. Washington (1856–1915),[40] a leading African American educator and public figure in the late nineteenth and early twentieth century. The subject of considerable controversy in current historical scholarship, Washington advocated self-advancement through discipline and hard work, but also accommodated European-American social expectations, urging African Americans to improve their standing by developing agrarian and domestic skills rather than political activism. Puryear's ladder, suspended over the floor and increasingly inaccessible as it reaches the top, suggests a number of ambiguous issues surrounding Washington and the principles he advocated. The ladder can—perhaps with difficulty—be climbed, but ultimately access to the top is denied. There is, however, no simple reading of this object, and any number of differing interpretations are possible. The work might comment on how hopes of success can be thwarted by the current social and economic system. It might also suggest the nobility, even heroism, of striving toward goals in spite of insurmountable odds.

Puryear has explored the ladder motif in two other works. In 1995 he developed an installation proposal for a 250-foot handmade ladder in Tokyo.[41] This ladder was also intended to diminish in width over distance, narrowing gradually to the top. The Tokyo project was cancelled and Puryear's proposal never realized, but in 1998–99 he developed another work based on the concept of a ladder for a temporary installation commissioned by the Festival D'Automne in Paris. Titled *This Mortal Coil* (fig. 17), this monumental sculpture took the form of a spiraling staircase that unfurled upwards to a height of 85 feet in the seventeenth-century Salpêtrière church. The stairs, which were made of massive red cedar timbers in the lower section, became increasingly lighter as they ascended, turning into muslin in the upper section so that they seemed to evaporate or vanish into the heights of the vaulted ceiling. Suggestions of transformation were reinforced formally in the work as it moved from the solid cedar to the diaphanous muslin.

The ladder is rich with associations. It often refers to ambition, and in many cultures it is a symbol of ascension,[42] or in more spiritual terms, transcendence, from the mortal to the celestial realms. In *Ladder for Booker T. Washington,* as in *This Mortal Coil* and many of Puryear's sculptures, form, process, and idea coalesce into a symbolically charged object.

Right: *Ladder for Booker T. Washington* as photographed on the floor of the artist's studio in June 2000. In the exhibition, the ladder was installed vertically, suspended off the ground.

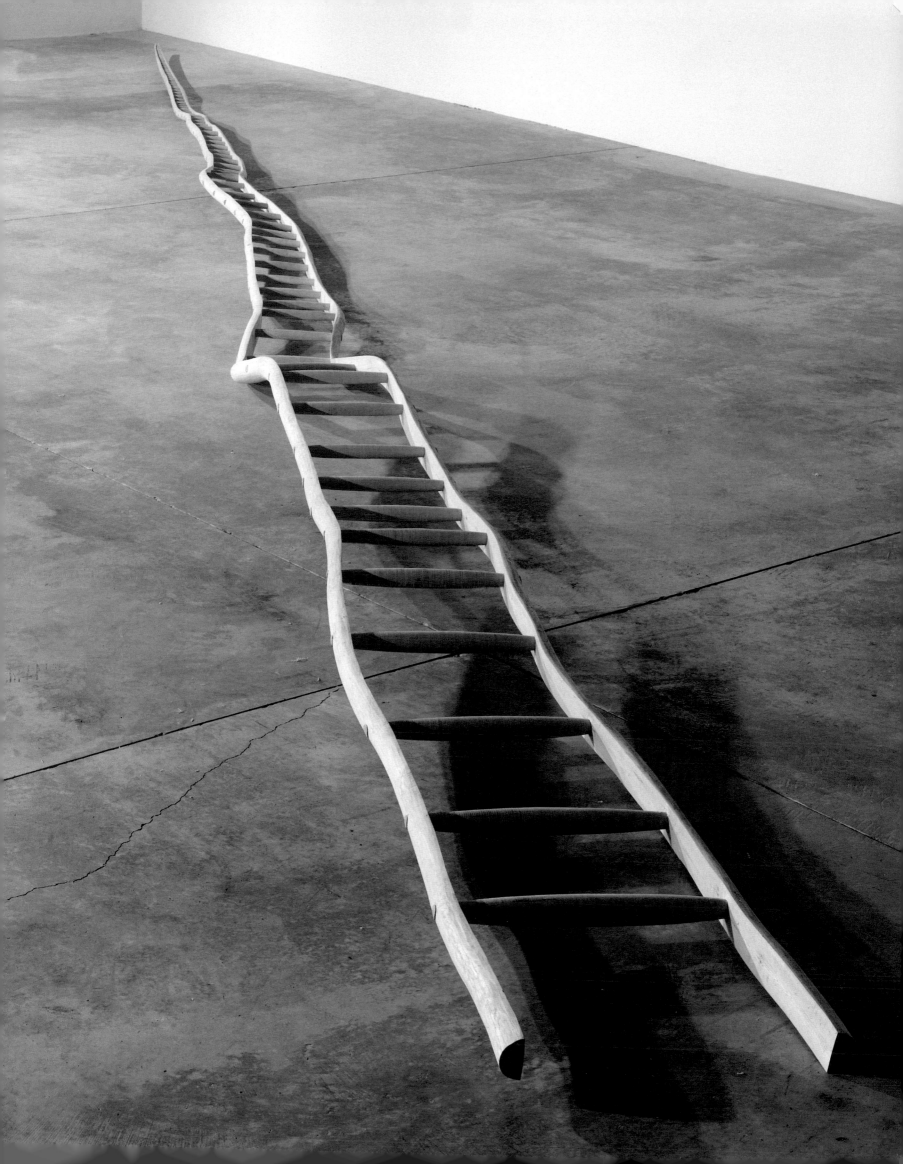

UNTITLED, 1997

Painted cedar and pine

68 x 57 x 51 in. (172.72 x 144.78 x 129.54 cm)

Promised gift of Agnes Gund to

The Museum of Modern Art, New York

Cat. No. 8

"Sculpture," Puryear has commented, "for me is an activity, not so much a product or result: it has to be charged but at the same time it should be as succinct as possible."[43] *Untitled,* 1997, embodies these ideas: majestic and serene, its minimalist form is both powerful and evocative. Like *Untitled,* 1995, or *Confessional,* 1996–2000, this sculpture suggests a monumental head but could also represent a mono-lith—a marker of a remote civilization—or perhaps a giant talisman, embodying some unknown or secret knowledge. Enriched by the simultaneous absorption and reflection of light from its polished black surface, this mysterious "totally closed" and "completely sheathed"[44] form is silently engaging.

This sculpture recalls *Self,* 1978 (fig. 7), which was similarly constructed by bending, wrapping, and gluing thin layers of cedar over a wooden frame and then painting the surface. Like *Self,* the sculpture appears solid but is in fact hollow; and as in many of Puryear's works, this paradox or juxtaposition of opposing ideas is intrinsic to the piece. Works such as these "almost allegorically demonstrate the deception of appearance."[45] In *Untitled,* 1997, Puryear invites the viewer to savor not only a beautiful object but to ponder the dynamics between surface and interior and the reality of appearances.

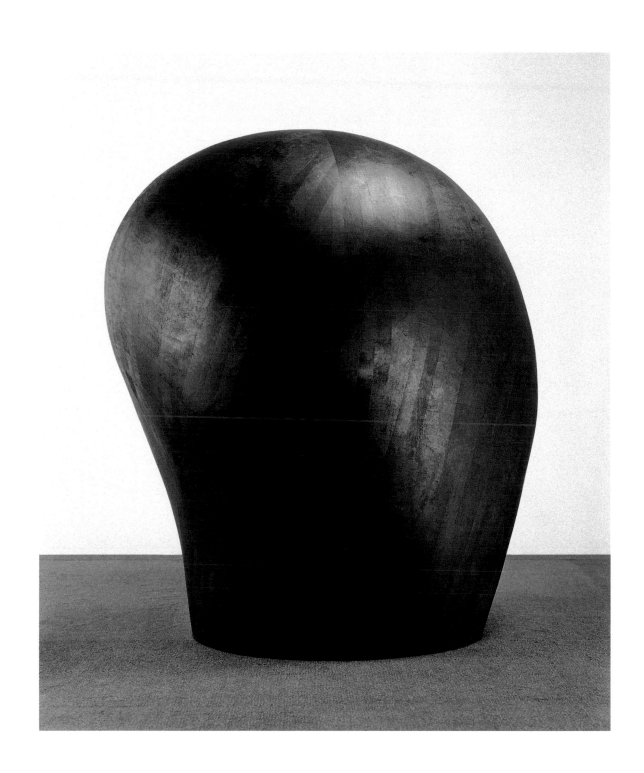

UNTITLED, 1997

Wire mesh and tar

66 x 76 ½ x 37 ¼ in. (167.60 x 194.30 x 94.60 cm)

The Detroit Institute of Arts

Founders Society Purchase, W. Hawkins Ferry Fund; Chaim, Fanny, Louis, Benjamin, Anne, and Florence Kaufman Memorial Trust; Andrew L. and Gayle Shaw Cambden Contemporary and Decorative Arts Fund; Mary Moore Denison Fund, with funds from the Friends of Modern Art; the Friends of African and African American Art; Lynne and Stanley Day; Gilbert and Ann Hudson; Burt Aaron; David Klein; Desiree Cooper and Melvin Hollowell, Jr.; Dr. Edward J. Littlejohn; Jeffrey T. Antaya; and Nettie H. Seasbrooks.

Cat. No. 9

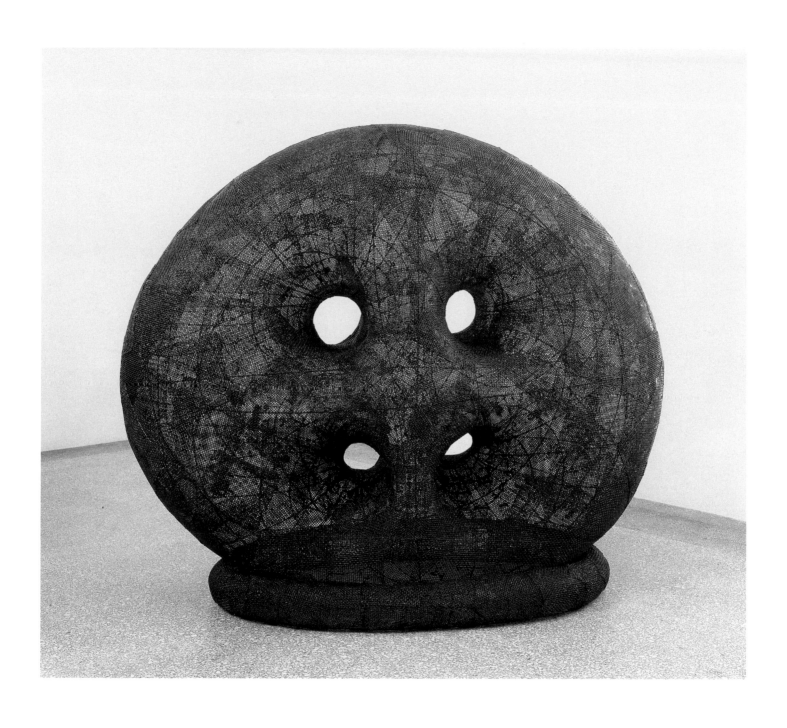

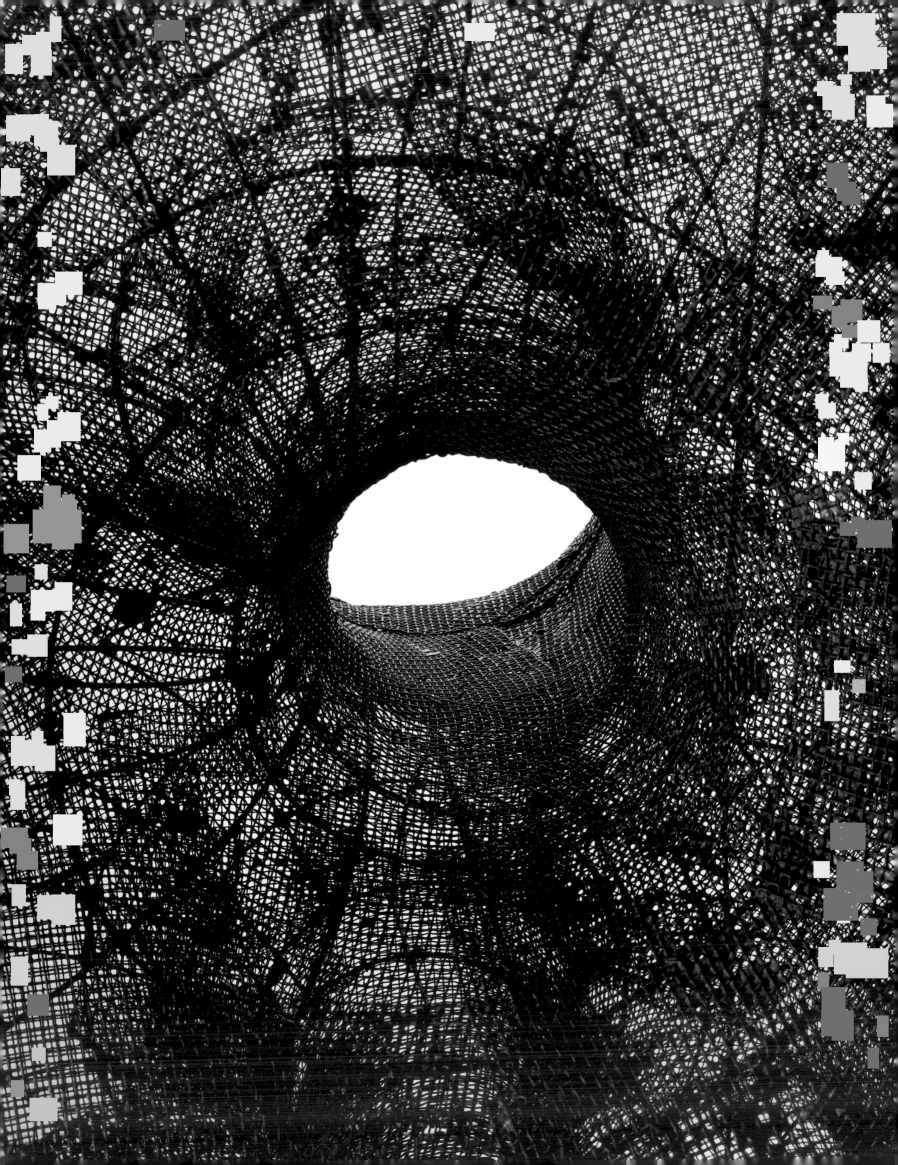

In the late 1970s and early 1980s, Puryear explored the archetypal shape of the circle in a number of wall sculptures created in the form of large wooden rings. Here Puryear has used steel wire, wire mesh, and tar to transform the circle into a freestanding object. The sculpture is transparent, and light filtering through its wire mesh body gives the work an almost ethereal presence.

Although reminiscent at first glimpse of a button, the sculpture soon becomes strangely alive, with its owl-like face, puffed cheeks, and four holes peering like quizzical eyes at the viewer. The "veined" interior, visible through the wire mesh "skin," appears to expand and contract almost as if it were pulsing like some microscopic organism, an impression reinforced by the flowing network of curved steel rods that constitute its framework. From another vantage point, the sculpture seems inflated and remarkably buoyant, and as one moves around the piece the great volume it occupies becomes apparent.

At the same time, as one looks through the wire mesh to the opposite side of the interior, the front surface appears to recede into the back surface. This subtle effect, together with the continuous surface that extends through the four holes as well as around the sculpture, creates a sense of movement—without beginning or end—throughout the piece. Being able to "see the whole thing flow through itself,"[46] as Puryear has remarked, also contributes to the intriguing nature of this work.

CONFESSIONAL, 1996–2000

Wire mesh, tar, and wood

77 $\frac{7}{8}$ x 97 $\frac{1}{4}$ x 45 in. (197.80 x 247.02 x 114.30 cm)

Collection of the artist

Cat. No. 10

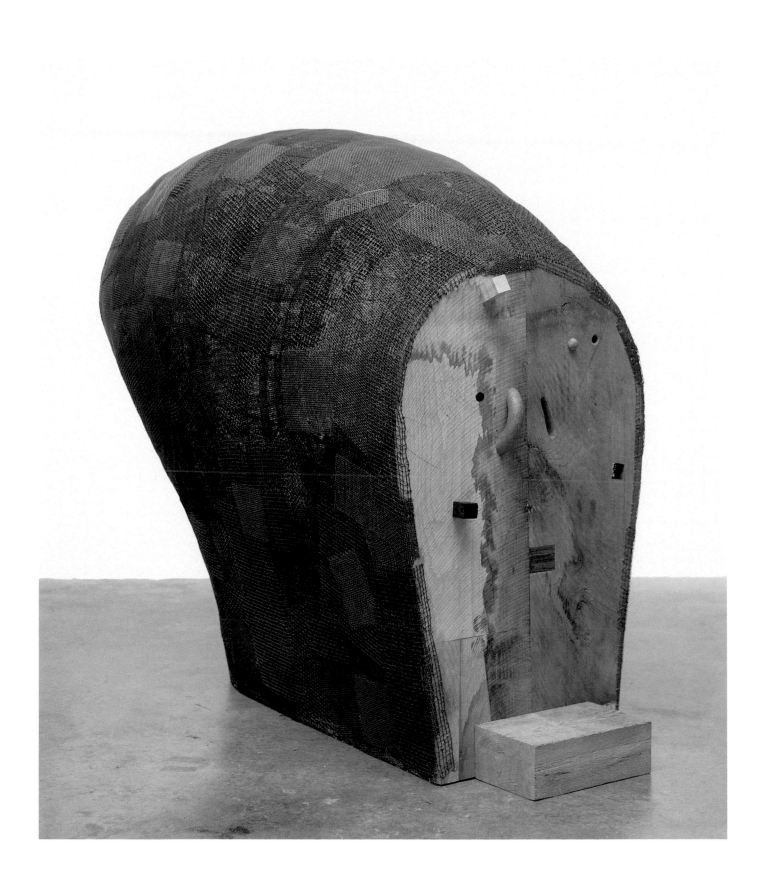

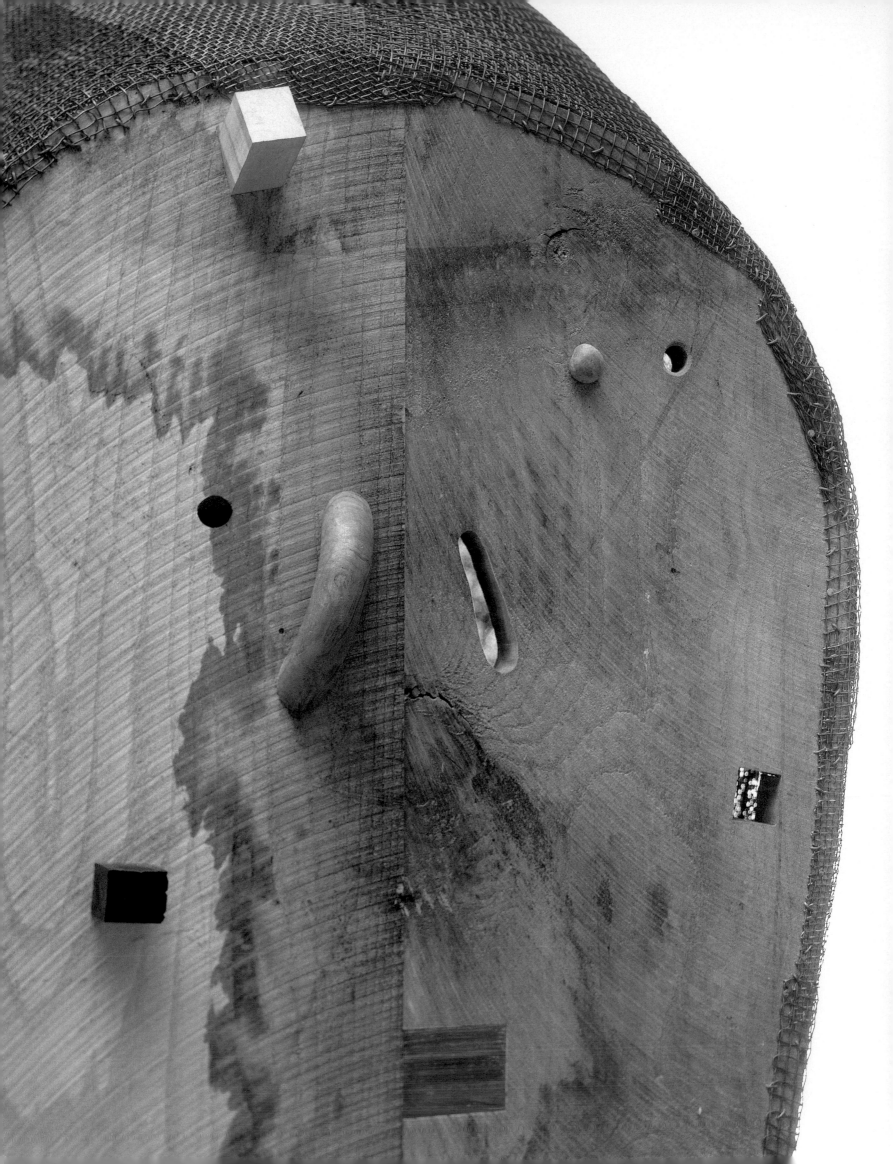

The massive, bulging form of this wire mesh, tar, and wood sculpture aggressively asserts its presence. Dark and brooding, the work might be perceived as an enormous head, a tomb, or a vessel for the dead. The structure also hints at a rudimentary shelter or hut.

Since creating *Cedar Lodge* in 1977, a huge hut or tentlike structure, Puryear has made a number of works that allude to dwellings. The yurt, a portable structure used by semi-nomadic people in central Asia, has played an important role in his work,[47] and was the inspiration for a number of sculptures such as *Where the Heart is (Sleeping Mews),* 1977,[48] or the installation for Documenta IX, 1992, in Kassel, Germany. *For Beckwourth,* 1980; *Vault,* 1984; and *Sanctum,* 1985, also allude to fundamental notions of shelter, protection, or sanctuary.

The domed *Confessional,* covered with a "patch-work quilt" of wire mesh squares, invokes a shelter not only for the body but for the soul. Light diffused through the wire mesh emanates from the sculpture and contributes to its mysterious aura. By adding a kneeling stool, Puryear makes reference to a confessional, the enclosed chamber in a Catholic church where a priest receives confessions. Here, protected by a screened barrier, full disclosure is invited, the conscience unburdened, and sanctuary offered.

The small cubes, tiny knob, and handle-like form affixed to the front panel of *Confessional* resemble a Harlequinesque face, with eyes, nose, and mouth all askew. More significantly, the front panel is punctured. "These openings to the inside,"[49] as Puryear has described them, provide for partial entry; and though this door or portal is closed, it can be spoken through or peered into. And much like the screen behind which the sinner confesses, or a mirror in which one's face is reflected, the sculpture invites discourse with the innermost recesses of one's being. *Confessional* offers a sacred—or perhaps uneasy—place of refuge, and an invitation to confront one's self.

HORSEFLY, 1996–2000

Wire mesh, tar, wood, and tinted glass

97 x 95 ³/₄ x 79 in. (246.38 x 243.21 x 200.66 cm)

Collection of The Edward R. Broida Trust

Cat. No. 11

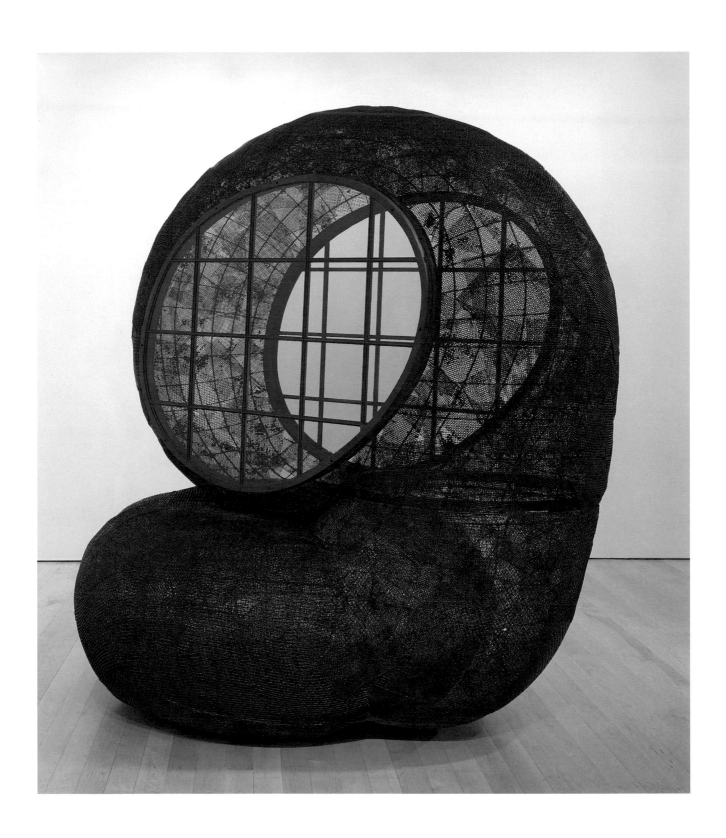

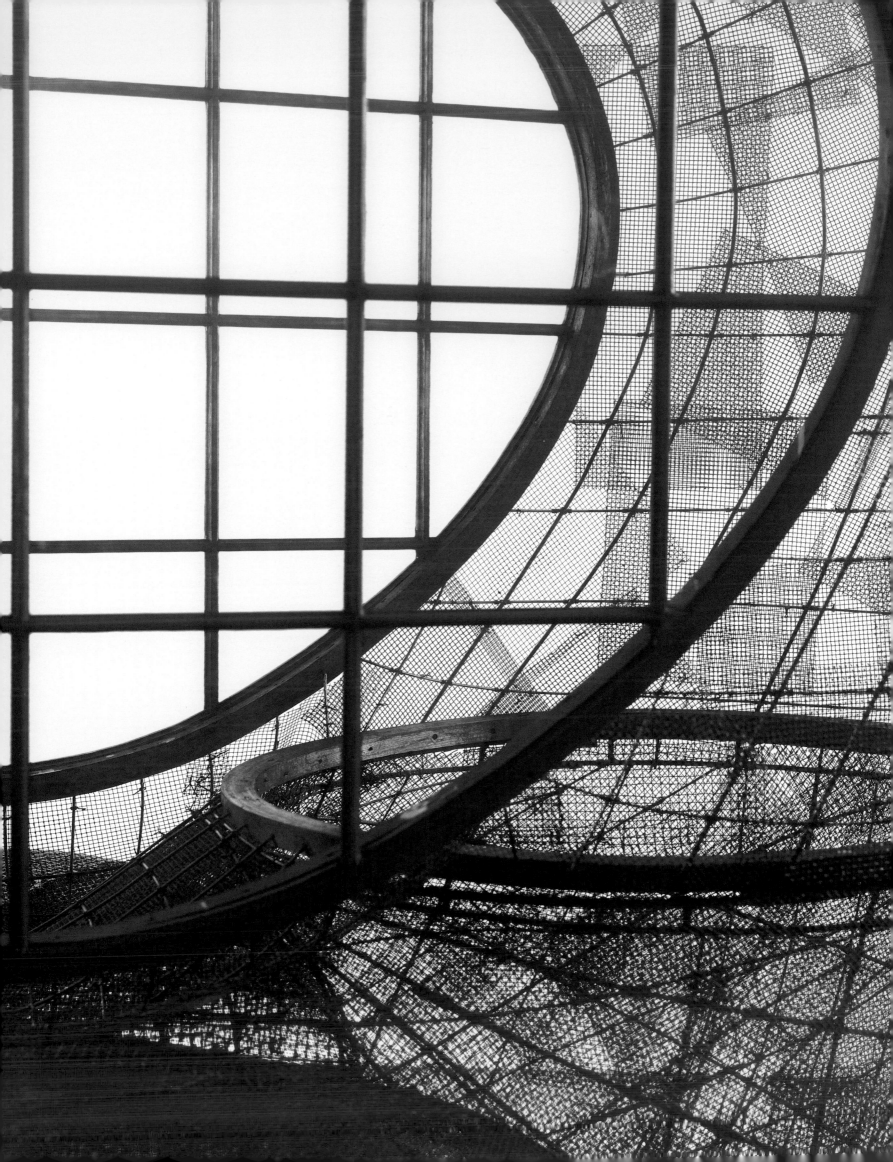

Puryear worked periodically on this sculpture over the course of four years, an extended gestation period not atypical for Puryear's works of the late 1990s. The importance of process and craftsmanship in Puryear's work can be seen in his extensive use of wire tying throughout this piece. The snail-shaped upper section, for example, made with a lattice of steel rods carefully wrapped and tied together with wire at each intersection, is a feat of disciplined precision and labor.

Puryear uses glass for the first time in this sculpture, a material that interests him because "like tar-covered wire mesh, tinted glass can appear both obscured and translucent at the same time."[50] The two large window-paned ovals on each side of the sculpture suggest architectural references, and the juxtaposition of the rigid lines in the mullioned windows with the sculpture's bulging form brings into play issues such as geometric versus organic and planar versus curvilinear.

For all its formal intricacies, *Horsefly* is striking first and foremost for its sheer physical presence—due not only to its monumental size and unusual shape, but to the sensual and metaphoric impact of its materials. While Puryear uses tar with wire mesh because it enables him to achieve varying degrees of opacity, both materials are nonetheless charged with history, memory, and meaning. Tar is shiny and has a distinctive odor; it is used as a sealant for wood planks to keep boats afloat and as an inexpensive roofing material. In both cases tar keeps out water and keeps the elements at bay, serving as a protective substance. Yet in nature, large tar pits once entrapped birds, small mammals, even mammoths. Wire and wire mesh inevitably suggest cages, chicken coops, traps, and forms of imprisonment. Alternately and perhaps more significantly, glass and wire mesh are used in windows and screen doors—both of which are thresholds or

"crossings" from the outside to inside, from one place or reality to another. It is perhaps this aspect of *Horsefly* that is most engaging. And while the sculpture's interior is visible, it remains out of reach, barred by wire mesh and sealed windows.

The sculpture could also suggest a blackened vessel, a time machine, or perhaps Jules Verne's sea machine—with large glass windows through which an undiscovered underwater world can be seen. The title of this sculpture, however, is *Horsefly,* and with its organic form and oval windows or large "eyes" on each side a resemblance can be construed. Given that the horsefly is a tenacious, blood-sucking insect, the sculpture assumes an ominous, even malevolent presence. Whether seen as a metaphor for an unrelenting nuisance, a bleak, life-draining force, or a conduit of passage, *Horsefly* offers an extraordinary range of metaphoric possibilities.

BRUNHILDE, 1998–2000

Cedar and rattan

93 ½ x 112 ¾ x 73 ½ in. (237.49 x 286.39 x 186.70 cm)

Collection of the artist

Cat. No. 12

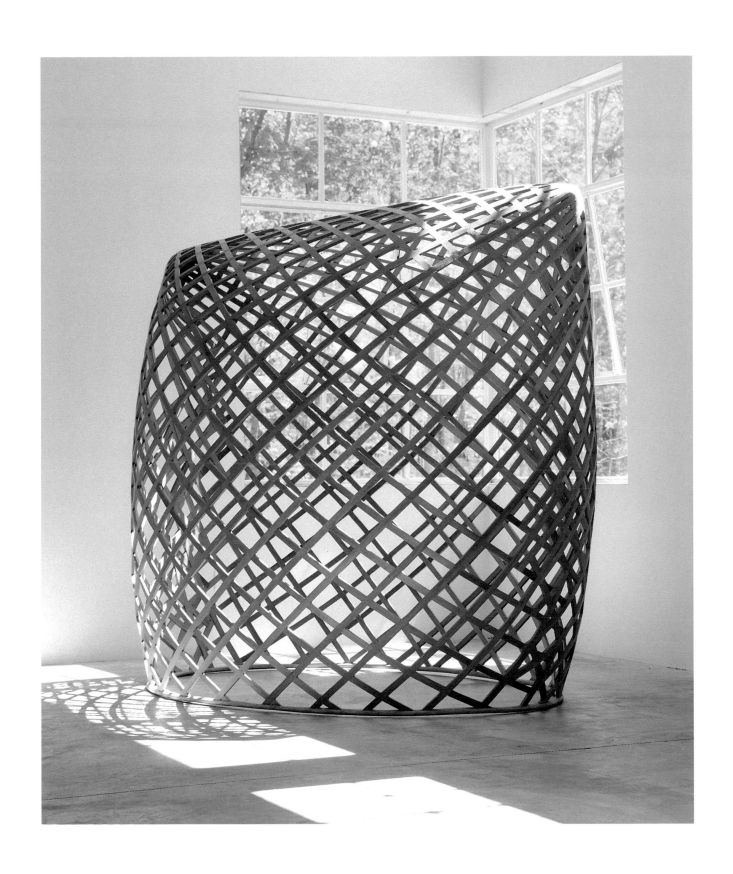

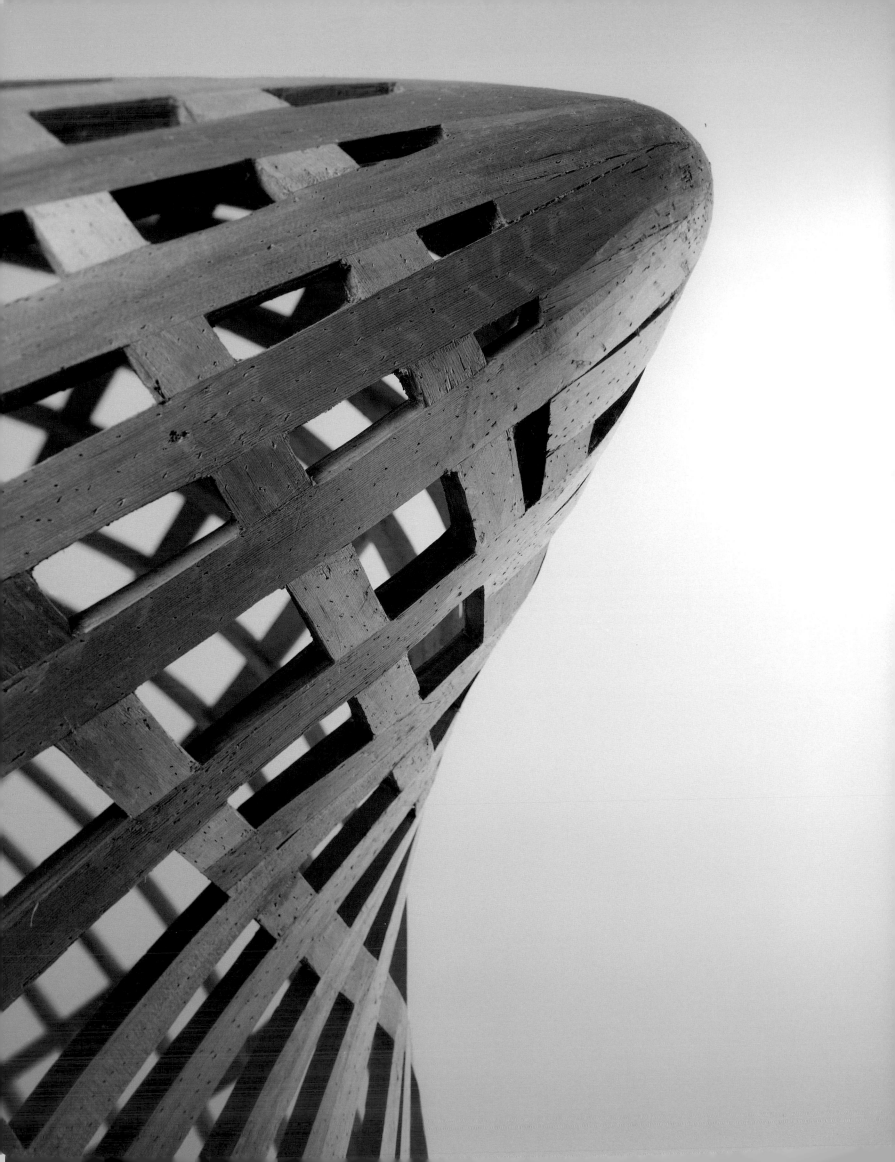

This elegant sculpture, with its bent, cone-shaped corners, resembles a giant grain sack or flour bag. Its latticed structure is made with laminated strips of red cedar that flow upwards from an oval base and around the work's swelling form to converge at the top corners. The strips make a rich pattern of fluid, intersecting lines that enclose and define the sculpture's form, while at the same time activating its surface and interior with a sense of sweeping movement and energy. Despite its great mass the sculpture appears light and airy; it is transparent and porous, with an interior that is resplendent with the kinetic interaction of line, light, and shadow. The unique shape, exquisite craftsmanship, and sheer size of this work make it without question a masterpiece.

The woven or basketlike construction of *Brunhilde* recalls a number of works Puryear has created using basketry techniques: the latticed cedar structure in *Desire,* 1981; woven strips of red cedar in *Old Mole,* 1985 (fig. 2), and woven rattan rods in *Charm of Subsistence,* 1989 (cat. no. 2); or even the latticed steel columns in the public commission *North Cove Pylons* (fig. 8). In *Brunhilde,* however, the cedar strips are not woven; there is, in fact, no interlacing, and what might appear as a simply constructed piece is in fact quite complex.

Puryear made each laminated strip by cutting pieces of wood to size, then gluing, stapling, and clamping them together into layers of five. Rather than interlacing the cedar strips, Puryear created the lattice by laboriously cutting, fitting, and joining each cross-section to create a smooth continuous surface. *Brunhilde* exemplifies not only Puryear's technical virtuosity but also his dedication to craftsmanship as a means to realizing his art. Puryear has commented that the sculpture "is an idealized form realized with a great deal of labor and thought . . . it certainly took a lot longer to create than most things I've ever done."[51]

Like many of Puryear's sculptures, *Brunhilde* is multifaceted in its form, its referents, and its possible interpretations. From one vantage point, it might resemble a vessel or sack, but from its narrowest side it metamorphoses into what might be an abstracted bird's head or beak, or even the prow of a surging ship. As a work in progress, Puryear referred to this sculpture as resembling a flour bag; recently he has titled it *Brunhilde,* after the stereotype of the Wagnerian opera character, "an incredibly overblown or inflated person."[52] As Puryear has admitted, "irony and humor are not altogether absent from my work."[53] Yet in Norse mythology Brunhilde is the most famous of the beautiful, fierce, and tempestuous Valkyries, goddesses who appeared to dying Viking warriors and led them to heaven.[54] Brunhilde thus served as a divine messenger, a conduit from the mortal to the heavenly realms, and a sculpture bearing her name might similarly invoke themes of transcendence.

Puryear developed the concept for this work years before he began to realize it. He had in mind a sculpture that was larger than a person, that could be walked around and looked into.[55] His aim in such works was "to activate space while leaving it open. Usually sculpture is more or less closed, secret. I am interested in describing form without hiding the interior space."[56] These comments also apply to *Brunhilde;* its latticed structure functions as a net that contains the space within while simultaneously leaving it open to view.

Contradictions or oppositions—open and closed, inside and outside—come into play here, as do notions of shelter and entrapment, freedom and captivity. One senses in this work a presence that is barely contained, and the sculpture seems to be almost bursting at the seams. *Brunhilde* is alive with subtle tensions and the complex interplay of interior and exterior forces of energy.

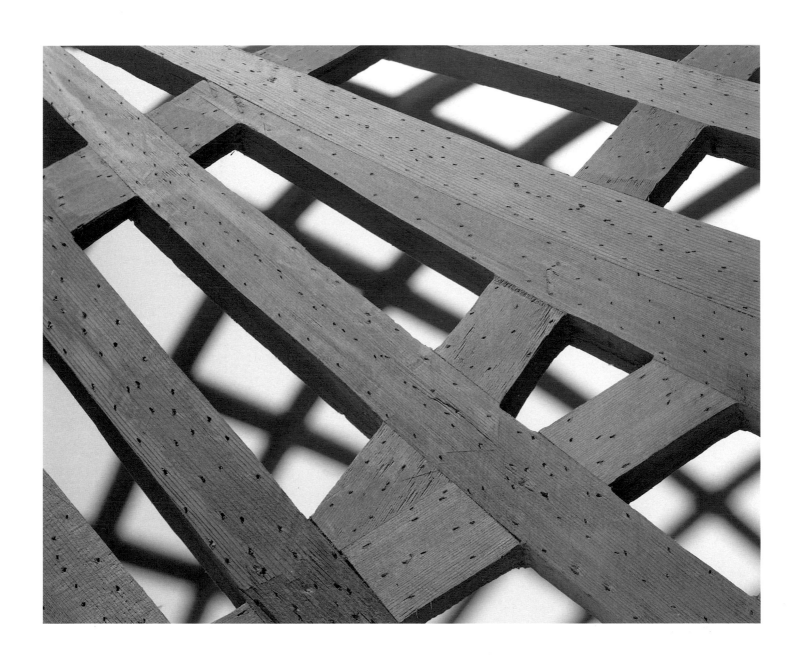

NOTES

1. Kellie Jones, *Martin Puryear*, exh. cat. for the 20th International São Paulo Bienal (New York: Jamaica Arts Center, 1989), 13.

2. See, for example, Martin Puryear's comments in Steven Henry Madoff, "Sculpture Unbound," *ARTnews,* November 1986, 105.

3. Allan G. Artner, *Chicago Tribune,* November 3, 1991, 12.

4. Hugh M. Davies and Helaine Posner, *Martin Puryear* (Amherst: University Gallery, University of Massachusetts at Amherst, 1984), 31.

5. During this time Puryear worked briefly with the renowned master cabinetmaker James Krenov, whose sensitivity to materials and emphasis on the value of labor in making works of art was an important influence. See Neal Benezra, *Martin Puryear* (Chicago and New York: The Art Institute of Chicago and Thames and Hudson, 1991), 17.

6. Davies and Posner, *Martin Puryear,* 30.

7. Martin Puryear in a conversation with Elaine King in his Chicago studio, March 1987. Quoted in *Martin Puryear: Beyond Style, The Power of the Simple,* 1987 exh. broch., Carnegie Mellon University, Hewlett Art Gallery, Pittsburgh.

8. See related comments, Michael Kimmelman, *New York Times,* March 1, 1992, 35.

9. Robert Storr, *Martin Puryear* (London and Chicago: Thames and Hudson and the Art Institute of Chicago, 1991), 129.

10. Martin Puryear quoted in an interview with Geneviève Breerette, originally printed in *Le Monde,* September 18, 1999, reprinted in the brochure accompanying the installation *This Mortal Coil,* 1999, commissioned by the Festival D'Automne at the Chapelle Saint-Louis de la Salpêtrière, Paris.

11. Susan Lubowsky, *Enclosing the Void: Eight Contemporary Sculptors* (New York: Whitney Museum of American Art at the Equitable Center, 1988), 5.

12. Davies and Posner, *Martin Puryear,* 23.

13. See "Commissions of the 1990s," p. 62. For a discussion of some of Puryear's public art commissions of the 1990s see Adam Weinberg, *Visions of America: Landscape as Metaphor in the Late Twentieth Century* (Denver, Colo., and Columbus, Ohio: Denver Art Museum and the Columbus Museum of Art, 1994), 212–13. Also, see Jan Carden Castro, "Martin Puryear: The Call of History," *Sculpture* 17, no. 10 (December 1998): 16–21.

14. *Untitled,* 1997 (fig. 21), the copper sculpture in the collection of the Albright-Knox Art Gallery, is a sister piece to *Untitled,* 1997 (cat. no. 8), which is made of painted cedar and pine. Both works are comparable is size and shape; however, the copper piece is perforated with a multitude of tiny holes.

15. For example, a vessel or container-like form is suggested in *Charm of Subsistence,* 1989 (cat. no. 2); *No Title,* 1993–95 (fig. 9); *In Sheep's Clothing,* 1996–98 (fig. 20); and *Brunhilde,* 1998–2000 (cat. no. 12). Shelters or human abodes reappear in a number of Puryear's works, including the hutlike *For Beckwourth,* 1980, and the yurtlike installation Puryear created for Documenta IX (1992).

16. For example, *Lever #2,* 1989 (cat. no. 1), hints at some form of hunting implement such as a net or a cage. Works of the 1990s that reference tools include the iron-shaped wire mesh sculpture *Dumb Luck,* 1990 (fig. 19), and the bronze pedestal piece *Untitled,* 1994 (fig. 10). *No Title,* 1993–95 (fig. 9), literally contains a tool: though not immediately visible, there is an anvil on a tree trunk inside the wire mesh sculpture. *Untitled,* 1997 (fig. 13), alludes to a bird or type of waterfowl as well as to a primitive construction crane or pulley.

17. See Martin Friedman et al., *Visions of America: Landscape as Metaphor in the Late Twentieth Century* (Denver, Colo., and Columbus, Ohio: Denver Art Museum and the Columbus Museum of Art, 1994), 22.

 The cluster of podlike forms evoked by *Alien Huddle,* 1993–95 (cat. no. 4), the gourdlike wire mesh sculpture *Untitled,* 1995 (cat. no. 6), or *Horsefly,* 1996–2000 (cat. no. 11), all suggest plant or animal forms.

18. Birdlike forms figure prominently throughout Puryear's iconography, from works that might suggest birds' heads or beaks such as *Old Mole,* 1985 (fig. 2) or the tips of *Brunhilde,* 1998–2000 (cat. no. 12), to works that allude to falcons, such as the group of small birdlike forms in bronze or wood that have been exhibited individually or as part of the installation *Where the Heart Is (Sleeping Mews),* 1990. Falcons, which have held a long-time fascination for Puryear, might signify spiritual liberation. See Benezra, *Martin Puryear,* 27.

 Subtle references to boats in Puryear's work are made in sculptures such as *His Eminence,* 1993–95, which evokes the image of a boat sailing off, or in works such as *Don-Jon,* 1988 (fig. 15), which might suggest a ship's rudder. Puryear's use of open wood frameworks—much like those used in shipbuilding—also prompts nautical associations. See, for example, *Bower,* 1980 (fig. 5).

19. James Hall, *Illustrated Dictionary of Symbols in Eastern and Western Art* (Boulder, Colo.: Westview Press, 1994), 11.

20. Ibid., 72.

21. Carole Gold Calo, "Martin Puryear: Private Objects, Evocative Visions," *Arts Magazine,* February 1988, 93.

22. Telephone conversation with the author, August 1, 2000.

23. Ibid.

24. Nancy Princethal, "Intuition's Disciplinarian," *Art in America,* January 1990, 132.

25. Martin Puryear reiterated this reference in a telephone conversation with the author on September 7, 2000. See also Benezra, *Martin Puryear,* 49.

26. Conversation with the author, March 1995.

27. Charlie Wylie, *The Saint Louis Museum Bulletin,* Winter 1995, 38.

28. Davies and Posner, *Martin Puryear,* 23.

29. Patterson Sims, *Selected Works* (Seattle, Washington: Seattle Art Museum, 1991), 134.

30. Susan Hagen, "Growth Rings and Heartwood," *Woodwork,* August 1999, 75.

31. Conversation with the author in his studio, June 2000.

32. Benezra, *Martin Puryear,* 52.

33. Hagen, "Growth Rings," 73.

34. See George Melrod, "Skill, Vision, and Craft," *Art & Antiques,* June 1995, 40.

35. Michael Kimmelman, "Martin Puryear," *New York Times,* March 10, 1995, C20.

36. Melrod, "Skill, Vision, and Craft," 40.

37. Martin Friedman in *Modern Sculpture at The Nelson-Atkins Museum of Art: An Anniversary Celebration,* exh. cat., Nelson Gallery Foundation, Kansas City, 1999, with essays by Deborah Emont Scott and Martin Friedman, 27.

38. John Ash, "Martin Puryear," *Artforum,* October 1995, 98.

39. Conversation with the author in his studio, May 11, 2000.

40. Born a slave in Franklin County, Virginia, in 1856, Booker T. Washington established the famed Tuskegee Institute and became a prominent intellectual and political leader. For more information see Kwame Antony Appiah and Henry Louis Gates, Jr., eds., *Africana: The Encyclopedia of African and African American Experience* (New York: Basic Civitas Books, 1979), 1958–59.

41. The proposal was made for a vast space inside the Tokyo International Forum building.

42. For example, in the Old Testament, Jacob's ladder reached from earth to heaven where the angels and God resided (Genesis 28:12). In the Dogon culture of Africa, the ladder represents an allegorical link between the earthly world and the world of the spirits. Arthur Schwartz, "Le Forgeron Celeste," *Arts Afrique Noire 33* (Spring 1980), 21.

43. Telephone conversation with the author, December 22, 2000.

44. Ibid., August 1, 2000.

45. Judith Russi Kirshner, "Martin Puryear in the American Grain," *Artforum* 30 (December 1991): 61.

46. Telephone conversation with the author, August 1, 2000.

47. See Benezra, *Martin Puryear,* 27.

48. *Where the Heart Is (Sleeping Mews)* has been recreated three times for exhibitions: in 1981 at the gallery in Seattle; in 1987 for "Martin Puryear: Public and Personal," Chicago Public Library Cultural Center; and in 1990 in "Connections: Martin Puryear," Museum of Fine Arts, Boston.

49. Telephone conversation with the author, August 1, 2000.

50. Ibid., November 28, 2000. Puryear used blown glass in a small work of 1992, but in *Horsefly* he used flat or sheet glass for the first time.

51. Telephone conversation with the author, September 13, 2000.

52. Ibid.

53. Ibid.

54. In Norse mythology, Brunhilde was the most famous of the nine Valkyries, daughters of the god Odin. They were beautiful but fierce women who dressed splendidly in full armor—with breastplates, winged helmets, and swords— and rode through the clouds on winged horses. The Vikings believed that when a warrior was about to die in battle, he would suddenly see a Valkyrie who would take him into the sky and transport him to the heavenly realm of Valhalla. *Comptons Encyclopedia* (1998). *Valkyries.* Retrieved September 14, 2000 from the World Wide Web: http://www.comptons.com/encyclopedia/ARTICLES/0175/01873408_A.html

55. Telephone conversation with the author, August 1, 2000.

56. Breerette interview.

Fig. 14
PURYEAR'S STUDIO, 1996
Left to right: section of *Vessel,* 1997, collection of the artist; section of *Untitled,* 1997 (fig.13); *Untitled,* 1997 (cat. no. 9); section of *Untitled,* 1997, collection of Lisa and Stuart Ginsberg, USA; section of *Confessional* (cat. no. 10).

CHECKLIST

Height precedes width followed by depth.

1. **LEVER #2,** 1989
 Ponderosa pine, ash, cypress, and rattan
 71 x 293 x 55 in. (180.34 x 744.22 x 139.70 cm)
 The Baltimore Museum of Art
 The Caplan Family Contemporary Art Fund and
 Collectors Circle Fund, BMA 1990.80

2. **CHARM OF SUBSISTENCE,** 1989
 Rattan and gumwood
 85 x 66 x 9 in. (215.90 x 167.64 x 22.86 cm)
 The Saint Louis Art Museum
 Funds given by the Shoenberg Foundation, Inc.,
 105:1989
 (Richmond and Miami only)

3. **THICKET,** 1990
 Basswood and cypress
 67 x 62 x 17 in. (170.18 x 157.48 x 43.18 cm)
 Seattle Art Museum
 Gift of Agnes Gund, 1990.32

4. **ALIEN HUDDLE,** 1993–95
 Red cedar and pine
 53 x 64 x 53 in. (134.62 x 162.56 x 134.62 cm)
 Private collection, New York

5. **PLENTY'S BOAST,** 1994–95
 Red cedar and pine
 68 x 83 x 118 in. (172.72 x 210.82 x 299.72 cm)
 The Nelson-Atkins Museum of Art
 Kansas City, Missouri
 Purchase: The Renee C. Crowell Trust, F95-16 A-C
 (Richmond and Miami only)

6. **UNTITLED,** 1995
 Wire mesh, tar, cedar, and particle board
 87 x 24 x 49 in. (220.98 x 60.96 x 124.46 cm)
 Virginia Museum of Fine Arts
 Museum Purchase: The Sydney and Frances Lewis
 Endowment Fund, 95.82

7. **LADDER FOR BOOKER T. WASHINGTON,**
 1996
 Ash
 438 x 22 ³/₄ x 1 ¹/₄ in. (1112.52 x 57.79 x 3.18 cm)
 Collection of the artist

8. **UNTITLED,** 1997
 Painted cedar and pine
 68 x 57 x 51 in. (172.72 x 144.78 x 129.54 cm)
 Promised gift of Agnes Gund to The Museum of
 Modern Art, New York
 (Richmond only)

9. **UNTITLED,** 1997
 Wire mesh and tar
 66 x 76 ¹/₂ x 37 ¹/₄ in. (167.60 x 194.30 x 94.60 cm)
 The Detroit Institute of Arts, 1991.1
 Founders Society Purchase, W Hawkins Ferry Fund; Chaim,
 Fanny, Louis, Benjamin, Anne, and Florence Kaufman
 Memorial Trust; Andrew L. and Gayle Shaw Cambden
 Contemporary and Decorative Arts Fund; Mary Moore
 Denison Fund, with funds from the Friends of Modern Art;
 the Friends of African and African American Art; Lynne and
 Stanley Day; Gilbert and Ann Hudson; Burt Aaron; David
 Klein; Desiree Cooper and Melvin Hollowell, Jr.; Dr. Edward J.
 Littlejohn; Jeffrey T. Antaya; and Nettie H. Seasbrooks; 1999.1.

10. **CONFESSIONAL,** 1996–2000
 Wire mesh, tar, and wood
 77 ⁷/₈ x 97 ¹/₄ x 45 in. (197.80 x 247.02 x 114.30 cm)
 Collection of the artist

11. **HORSEFLY,** 1996–2000
 Wire mesh, tar, wood, and glass
 97 x 95 ³/₄ x 79 in. (246.38 x 243.21 x 200.66 cm)
 Collection of The Edward R. Broida Trust

12. **BRUNHILDE,** 1998–2000
 Cedar and rattan
 93 ¹/₂ x 112 ³/₄ x 73 ¹/₂ in. (237.49 x 286.39 x 186.70 cm)
 Collection of the artist

BIOGRAPHY

Martin Puryear was born in 1941 in Washington, D.C. As a youth he read avidly in such subjects as archery, falconry, nature, and wildlife, and aspired to a career as a wildlife illustrator. He also enjoyed making things, and constructed bows and arrows, a guitar, furniture, and later, after college, a kayak and a canoe. At the Catholic University of America in Washington, D.C., Puryear first studied biology, one of the sources of his ongoing fascination with nature and natural forms, before becoming an art major specializing in painting. From 1964 to 1966 Puryear taught English, French, and biology as a Peace Corps volunteer in Sierra Leone, where he renewed his interest in woodworking and learned traditional techniques of wood craftsmanship from African carpenters. From 1966 to 1968 Puryear studied printmaking at the Swedish Royal Academy of Art in Stockholm, but at the same time he studied sculpture independently and shifted his artistic focus from painting to sculpture. Puryear received his Masters of Fine Arts degree in Sculpture from Yale University in 1971. His interest in woodworking techniques led him to study boatbuilding in various cultures around the world.

In 1968, Puryear had his first one-person exhibition at the Gröna Palletten Gallery in Stockholm, which was followed in the early 1970s by his first one-person exhibitions in the United States at the Fisk University Gallery in Nashville, Tennessee, and Henri 2 Gallery in Washington, D.C. During the 1970s Puryear established a studio in Brooklyn, New York, and taught at both Fisk University in Nashville and the University of Maryland in College Park. In 1977 the Corcoran Gallery of Art in Washington, D.C., presented Puryear's first one-person museum exhibition. That same year, a fire in his Brooklyn studio destroyed most of his work. At the end of the 1970s Puryear moved to Chicago.

During the 1980s, in addition to teaching at the University of Illinois in Chicago, Puryear exhibited widely throughout the United States. His work was featured in numerous exhibitions including the 1981 and 1989 Whitney Biennial Exhibitions at the Whitney Museum of American Art, New York. In 1983 Puryear traveled to Japan where he studied domestic and landscape architecture on a John S. Guggenheim Memorial Foundation Grant. A ten-year retrospective, organized by the University of Massachusetts at Amherst in 1984, traveled to five American museums. In 1989 Puryear became the first African American artist to represent the United States at the São Paulo Bienal in Brazil where he won the grand prize. That same year, Puryear was awarded the John D. and Catherine T. MacArthur Foundation Fellowship.

A mid-career retrospective of Puryear's work was organized by the Art Institute of Chicago in 1991 and traveled to the Hirshhorn Museum and Sculpture Garden in Washington, D.C., the Philadelphia Museum of Art, and the Museum of Contemporary Art in Los Angeles. Throughout the 1990s, Puryear's art received increasing national and international recognition. In 1992 he participated in Documenta IX in Kassel, Germany, and the French government invited him to be an artist-in-residence at the Atelier Calder in Saché, France, in 1992–93. In 1997, Puryear's work was the subject of a one-person exhibition at la Fundación "la Caixa" in Madrid, and was featured in an exhibition at the American Academy in Rome, where he was an artist-in-residence in 1997–98.

Puryear has created numerous public and private sculpture commissions. He is represented in the collections of major museums nationwide. He lives and works in New York state.

GRANTS AND AWARDS

1962 Baltimore Museum of Art Purchase Prize

1967 Scandinavian-American Foundation Study Grant

1969–71 Yale University grant for graduate study in sculpture

1975 Creative and Performing Artists Grant, University of Maryland

1976–77 CAPS Grant in Sculpture, New York Creative Artists Public Service Program

1977 Change, Inc., Robert Rauschenberg Foundation Grant

1977–78 National Endowment for the Arts, Individual Artist Fellowship, Washington, D.C.

Awarded studio at P.S.1, Long Island City, New York, Institute for Art and Urban Resources

1978 Creative and Performing Artists Grant, University of Maryland

1979 Residency at Yaddo, Invitational Community for Artists, Composers, and Writers, Saratoga Springs, New York

National Endowment for the Arts, Grant in Sculpture

1982 Louis Comfort Tiffany Grant

The John S. Guggenheim Memorial Foundation Grant

1988 The Francis J. Greenburger Foundation Award

1989 Brandeis Creative Arts Awards Citation for Sculpture, Brandeis University, Waltham, Massachusetts

John D. and Catherine T. MacArthur Foundation Fellowship Award

São Paulo Bienal grand prize for best artist, São Paulo, Brazil

1990 Skowhegan Medal for Sculpture, Skowhegan School of Painting and Sculpture, New York

1992 Elected to the American Academy and Institute of Arts and Letters, New York

1993 College Art Association Award

1994 Honorary Degree, Yale University, New Haven, Connecticut

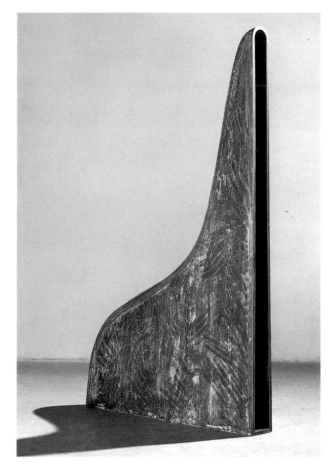

Fig. 15
DON-JON, 1989
Painted Ponderosa pine
81 ¼ x 49 x 5 ¼ in. (206.20 x 124.40 x 13.30 cm)
Collection of Robert Halff, Beverly Hills, California

COMMISSIONS OF THE 1990s

1991 *Griot New York,* set and costume designs in collaboration with Garth Fagan, Wynton Marsalis, and the Garth Fagan Dance Company. Brooklyn Academy of Music, Brooklyn, New York (temporary construction)

Courtyard for the New School for Social Research, New York (completed in 1997)

1992 *North Cove Pylons,* Battery Park City, New York, on the Hudson River, opposite the Statue of Liberty (completed in 1996) (fig. 8)

1993 *Everything That Rises,* University of Washington, Seattle, Washington, commissioned by the Washington State Arts Commission Art in Public Places Program in partnership with the University of Washington (completed in 1997)

Commission for Steven Oliver Ranch, Geyserville, California (completed in 1994)

1994 *Untitled* (stainless steel and granite bench), Faret Tachikawa Art Project, Tokyo, Japan

Bearing Witness, General Services Administration, Federal Triangle Project, Washington, D.C. (completed in 1998) (fig. 18)

1996 *Meditation in a Beech Wood,* The Wanås Foundation, Knislinge, Sweden (fig. 16)

1997 *That Profile,* a commissioned sculpture by the J. Paul Getty Trust for the Getty Center Tram Arrival Plaza, Los Angeles, California (completed in 1999) (fig. 12)

1998 *This Mortal Coil,* Chapelle Saint-Louis de la Salpêtrière, Paris, commissioned by the Festival D'Automne, Paris (completed in 1999; temporary installation September 24–November 1, 1999) (fig. 17)

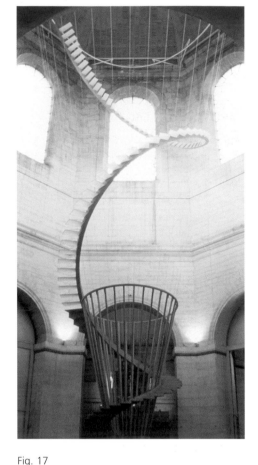

Fig. 17
THIS MORTAL COIL, 1998–99
Red cedar, stainless steel cable, aluminum, and muslin
85.0 x 39.4 x 52.5 ft. (26 x 12 x 16 m)
Chapelle Saint-Louis de la Salpêtrière, Paris

Fig. 16
MEDITATION IN A BEECH WOOD, 1996
Water reed thatched over a timbered frame
Approx. 15.8 ft. high (4.83 m)
The Wanås Foundation, Knislinge, Sweden

EXHIBITION HISTORY*

One-Person Exhibitions, 1989–2000

1989 *Martin Puryear,* Brooklyn Museum of Art,
Brooklyn, New York, November 18, 1988–
February 13, 1989

Martin Puryear, Margo Leavin Gallery,
Los Angeles, California, April 15–May 20

20th International São Paulo Bienal,
São Paulo, Brazil, October 14–December 10

1990 *Connections: Martin Puryear,* Museum of Fine
Arts, Boston, Massachusetts, March 17–July 8

1991 *Martin Puryear,* retrospective exhibition
organized by The Art Institute of Chicago,
November 2, 1991–January 5, 1992

Hirshhorn Museum and Sculpture Garden,
Washington D.C., February 5–May 10, 1992

Museum of Contemporary Art, Los Angeles,
August 2–November 11, 1992

Philadelphia Museum of Art, Philadelphia,
Pennsylvania, November 8, 1992–January 3,
1993

1993 *Martin Puryear,* Cleveland Center
for Contemporary Art, Cleveland, Ohio,
November 19, 1993–January 23, 1994

1995 *Martin Puryear: New Sculpture,* McKee Gallery,
New York, March 3–April 15

1997 *Martin Puryear,* Donald Young Gallery, Seattle,
Washington, February 28–May 3, 1997

Martin Puryear, Fundación "la Caixa," Madrid,
Spain, November 14, 1997–January 11, 1998

1999 *Drawing into Sculpture: Martin Puryear,*
The Contemporary Arts Center, Cincinnati, Ohio,
June 19–August 29

*Martin Puryear: Commission for the Getty
Center,* The J. Paul Getty Museum, Los Angeles,
California, November 23, 1999–January 9, 2000

2000 *Martin Puryear: The Cane Project,*
The Studio Museum in Harlem, New York,
October 15, 2000–January 7, 2001

* For exhibition history prior to 1989 see Neal Benezra, *Martin
Puryear* (Chicago and New York: The Art Institute of Chicago
and Thames and Hudson, 1991).

Fig. 18
BEARING WITNESS, 1994–98
Hammer-formed welded bronze plate
40 ft. high (12.19 m)
Commission for the Federal Triangle Project by
the General Services Administration, Washington, D.C.
Installed in 1998 at the Ronald Reagan Building Courtyard

Group Exhibitions, 1989–2000

1989 *Enclosing the Void: Eight Contemporary Sculptors,* Whitney Museum of American Art, New York, November 11, 1988–January 25, 1989

Introspectives: Contemporary Art by Americans and Brazilians of African Descent, The California African-American Museum, Los Angeles, California, February 11–September 30

Traditions and Transformations: Contemporary Afro-American Sculpture, The Bronx Museum of the Arts, Bronx, New York, February 21–May 27

1989 Whitney Biennial Exhibition, Whitney Museum of American Art, New York, April 27–July 9

New Sculpture: Tony Cragg, Richard Deacon, Martin Puryear, Susana Solano, Donald Young Gallery, Chicago, Illinois, May 3–May 27

Fig. 19
DUMB LUCK, 1990
Wire mesh, tar, and wood
64 x 94 x 36 in. (162.60 x 238.80 x 91.40 cm)
Collection of Harry W. and Mary Margaret Anderson

Art in Place: Fifteen Years of Acquisitions, Whitney Museum of American Art, New York, July 27–October 22

Selected Artists from the First Twenty Years, Max Protetch Gallery, New York, December 9, 1989–January 13, 1990

1990 *Objects of Potential: Five American Sculptors from the Anderson Collection,* Wiegand Gallery, College of Notre Dame, Belmont, California, February 6–March 30

Black USA, Museum Overholland, Amsterdam, Holland, April 7–July 29

The Decade Show: Frameworks of Identity in the 1980s, The New Museum for Contemporary Art, New York; New York Museum of Contemporary Hispanic Art; and the Studio Museum in Harlem, May 12–August 19

Selections from the Permanent Collection, Museum of Contemporary Art, San Diego, California, traveling exhibition, September 1990–September 1992

Group Show, McKee Gallery, New York, October 6–27

1991 *Devil on the Stairs: Looking Back at the Eighties,* Institute of Contemporary Art, University of Philadelphia, October 4, 1991–January 5, 1992; Newport Harbor Art Museum, Newport Beach, California, April 16– June 21, 1992

Reprise: The Vera List Collection, David Winton Bell Gallery, List Art Center, Brown University, Providence, Rhode Island, October 12–November 24, 1991

Small Scale Sculpture, Sewell Art Gallery, Rice University, Houston, Texas, October 24–December 14, 1991

1992 *Group Show,* Donald Young Gallery, Seattle, Washington, January 17–April 8

Allegories of Modernism: Contemporary Drawing, The Museum of Modern Art, New York, February 16–May 5

Process to Presence: Issues in Sculpture, 1960 to 1990, in conjunction with the 14th International Sculpture Conference, Locks Gallery, Philadelphia, June 3–July 17

Documenta IX, Kassel, Germany, June 13–September 20

1993 *Collective Pursuits: Mt. Holyoke Investigates Modernism,* Mt. Holyoke College Art Museum, South Hadley, Massachusetts, April 3–May 30

Yale Collects Yale, Yale University, New Haven, Connecticut, April 30–July 31

American Art in the 20th Century: Painting and Sculpture, 1913–1993, Martin Gropius-Bau, Berlin, Germany, May 8–July 23; Royal Academy of Arts, London, England, September 16–December 12

Drawing the Line Against AIDS, 45th Venice Biennial, Peggy Guggenheim Collection, Venice, Italy, June 13–November 7

Visual Arts Encounter: African Americans and Europe, Salle Clemenceau, Palais du Luxembourg, Paris

1994 *Putting Things Together, Recent Sculpture from the Anderson Collection,* Art Museum of Santa Cruz County, Santa Cruz, California, April 23–June 26, 1994

Landscape as Metaphor: Visions of America in the Late Twentieth Century, Denver Art Museum, Denver, Colorado, May 14–September 11, 1994; The Columbus Museum of Art, Columbus, Ohio, October 16, 1994–January 8, 1995

Group Show, Donald Young Gallery, Seattle, Washington, June 1–November 12, 1994

New Works on Paper: Sol LeWitt, Robert Mangold, Martin Puryear, Richard Serra, Donald Young Gallery, Seattle, Washington, September 23–November 22, 1994

1995 *The Material Imagination,* Guggenheim Museum SoHo, New York, November 18, 1995–January 28, 1996

1996 *Abstraction in the Twentieth Century: Total Risk, Freedom, Discipline,* Solomon R. Guggenheim Museum, New York, February 9–May 12, 1996

A Century of Sculpture: The Nasher Collection, Fine Arts Museum, San Francisco, October 1996–January 1997; Solomon R. Guggenheim Museum, New York, February–April 1997

Art in Chicago, 1945–1995, Museum of Contemporary Art, Chicago, November 16, 1996–March 23, 1997

1997 *Envisioning the Contemporary: Selections from the Permanent Collection,* Museum of Contemporary Art, Chicago, June 20–May 31

American Stories: Amidst Displacement and Transformation, organized by the Cultural Projects Division, Tokyo, Japan; traveled to five Japanese museums August 1997–September 1998

Nunzio, Martin Puryear: Forma Lignea, American Academy in Rome, Italy, December 19, 1997–February 22, 1998

1998 *The Edward R. Broida Collection,* Orlando Museum of Art, Orlando, Florida, March 12–June 21

The African-American Odyssey: A Quest for Full Citizenship, The Library of Congress, Washington, D.C., February 5–May 2

Face to Face: Art in the Public, Marlborough Chelsea, New York, May 9–June 27

Essence of the Orb, Michael Rosenfeld Gallery, New York, June 14–August 20

Narratives of African American Art and Identity: The David C. Driskell Collection, The Art Gallery of the University of Maryland, College Park, October 22–December 19 (traveling through 2001)

1999 *Weaving the World: Contemporary Art of Linear Construction,* Yokohama Museum of Art, Japan, June 26–August 22

The American Century: Art & Culture, 1900–2000, Part II, 1950–2000, Whitney Museum of American Art, New York, September 26–February 3

2000 *Making Choices,* The Museum of Modern Art, New York, March 16–September 25

Strength and Diversity: A Celebration of African-American Artists, Carpenter Center, Harvard University, Cambridge, Massachusetts, April 5–May 5

Celebrating Modern Art: The Anderson Collection, San Francisco Museum of Modern Art, San Francisco, California, October 7, 2000–January 15, 2001

New, McKee Gallery, New York, November 9–December 21, 2000

SELECTED BIBLIOGRAPHY

Major Exhibition Catalogues

Benezra, Neal. *Martin Puryear*. With an essay by Robert Storr. Chicago and New York: The Art Institute of Chicago and Thames and Hudson, 1991.

Boyden, Martha, ed. *Nunzio, Martin Puryear: Forma Lignea*. With an introduction by Peter Boswell and an essay by David Levi Strauss and Robert Storr. Rome: American Academy in Rome and Electa, 1997.

Davies, Hugh M., and Helaine Posner. *Martin Puryear*. Amherst: University Gallery, University of Massachusetts at Amherst, 1984.

Golden, Deven K. *Martin Puryear: Public and Personal*. With essays by Patricia Fuller and Judith Russi Kirshner. Chicago: Chicago Public Library Cultural Center, 1987.

Jones, Kellie. *Martin Puryear*. With an essay by Robert Storr. Exh. cat. for the 20th International São Paulo Bienal. Jamaica, New York: Jamaica Arts Center, 1989.

Juncosa, Enrique. *Martin Puryear*. With an essay by Michael Brenson. Barcelona: Fundación "la Caixa," 1997.

Additional Sources

Armstrong, Richard, et al. *Biennial Exhibition*. Exh. cat. New York: Whitney Museum of American Art, 1989.

Armstrong, Richard, and Susan C. Larsen. *Art in Place: Fifteen Years of Acquisitions*. Exh. cat. New York: Whitney Museum of American Art, 1989.

Arnason, H. H. *History of Modern Art*. 4th ed. Edited by Marla F. Prather. New York: Abrams, 1998.

Artner, Alan. "On Form and Function." *The Chicago Tribune*, November 3, 1991, 10, 12.

Ash, John. "Martin Puryear." *Artforum International* 34 (October 1995): 98.

Auping, Michael, and Susan Krane. *Structure to Resemblance: Work by Eight American Sculptors*. Exh. cat. Buffalo: Albright-Knox Art Gallery, 1987.

Baker, Kenneth. "Martin Puryear, Sympathy and Common Ground." *Artspace*, July/August 1992, 32–5.

Benezra, Neal, Gary Garrels, and Michael Auping, eds. *Celebrating Modern Art: The Anderson Collection*. Berkeley: University of California Press, 2000.

Berkowitz, Marc. "São Paulo Bienal: No Hidden Corners." *ARTnews* 89 (February 1990): 167.

Breerette, Geneviève. "Dans l'espace intérieur de Martin Puryear." *Le Monde Supplement*, September 18, 1999, 9. Reprinted in the brochure accompanying the commissioned installation *This Mortal Coil*. Paris: Festival D'Automne, 1999.

Brenson, Michael. "Shaping the Dialogue of Mind and Matter." *The New York Times*, November 22, 1987, sec. 2, 39.

___. "Doors of Art Opening." *The New York Times*, October 16, 1989, C15, C18.

___. "A Sculptor's Struggle to Fuse Culture and Art." *The New York Times*, October 29, 1989, 39.

___. "Memory of Hand." *Sculpture* 14 (May/June 1995): 28–35.

Boyd, Julia. *American Abstraction Now*. Exh. broch. Richmond: Institute of Contemporary Art of the Virginia Museum of Fine Arts, 1982.

Calo, Carole Gold. "Martin Puryear: Private Objects, Evocative Visions." *Arts Magazine* 62 (February 1988): 90–4.

Carboni, Massimo. "Nunzio/Martin Puryear." *Artforum* 36, no. 8 (April 1998): 124.

Castro, Jan Carden. "Martin Puryear: The Call of History." *Sculpture* 17, no. 10 (December 1998): 16–21.

Cateforis, David. *Objects of Potential: Five American Sculptors from the Anderson Collection*. Exh. broch. California: Wiegand Gallery, College of Notre Dame, 1990.

Catlett, Elizabeth, et al. *Traditions and Transformations: Contemporary Afro-American Sculpture*. New York: The Bronx Museum, 1989.

Cena, Olivier. "L'envol de l'escalier." *Télérama*, September 29, 1999.

Cotter, Holland. "Black Artists: Three Shows." *Art in America* 78 (March 1990): 164–71.

Crary, Jonathan. "Martin Puryear's Sculpture." *Artforum*, October 1979, 28–31.

Day, Holiday T. *1–80 Series: Martin Puryear*. Exh. broch. Omaha, Neb.: Joslyn Art Museum, 1980.

Documenta IX (1992), Kassel, Germany. Organized by Documenta and Museum Fridericianum Veranstaltungs. English language edition. Stuttgart: Cantz; New York: Abrams, 1992.

Drewel, Henry J., and David C. Driskell. *Introspectives: Contemporary Art by Americans and Brazilians of African Descent*. Los Angeles: California Afro-American Museum, 1989.

Drohojowska-Philp, Hunter. "Building a Vision from the Ground Up." *Los Angeles Times*, December 5, 1999, Calendar, 67.

Duncan, Michael. "New Puryear for the Getty." *Art in America*. No. 1 (January 2000): 23.

Failing, Patricia. "Black Artists Today, A Case of Exclusion." *ARTnews* 88, no. 3 (March 1989): 124–31.

Fineberg, Jonathan, ed. *Art Since 1940: Strategies of Being*. New Jersey: Prentice Hall, 1995.

Flam, Jack. "The View from the Cutting Edge." *The Wall Street Journal*, May 10, 1989.

Fonvielle-Bontemps, Jacqueline, et al. *Choosing: An Exhibit of Changing Perspectives in Modern Art and Art Criticism by Black Americans, 1925–1985*. Exh. cat. Hampton, Va.: Hampton University, 1985.

Francblin, Catherine. "Martin Puryear Globe Sculptor." *Beaux Arts Magazine*, October, 1999.

French, Christopher. *Edelson, Puryear, Scanga, Stackhouse*. Exh. broch. Washington, D.C.: Corcoran Gallery of Art, 1988.

Friedman, Martin. "Growing the Garden." *Design Quarterly* 141 (Fall 1988): 4–43.

Friedman, Martin, et al. *Painting and Sculpture from the Collection*. Minneapolis and New York: Walker Art Center and Rizzoli International, 1990.

Friedman, Martin, et al. *Visions of America: Landscape as Metaphor in the Late Twentieth Century*. Exh. cat. Denver, Colo., and Columbus, Ohio: Denver Art Museum and Columbus Museum of Art, 1994.

Friedman, Martin, Donna Harkavy, and Peter W. Boswell. *Sculpture Inside Outside*. Exh. cat. Minneapolis and New York: Walker Art Center and Rizzoli International, 1998.

Gast, Dwight V. "Martin Puryear: Sculpture as an Act of Faith." *Journal of Art* 2, no. 1 (September/October 1989): 6–7.

Gimenez, Carmen, and Steven A. Nash. *A Century of Sculpture: The Nasher Collection*. New York and San Francisco: Guggenheim Museum and Fine Art Museums of San Francisco, 1996.

Gips, Terry, et al. *Narratives of African American Art and Identity: The David C. Driskell Collection*. San Francisco: Pomegranate, 1998.

Goodman, Jonathan. "Martin Puryear." *ARTnews* 94 (September 1995): 142–3.

Hagen, Susan. "Growth Rings and Heartwood: An Abridged Introduction to Contemporary Sculpture in Wood, Part 1." *Woodwork* 58 (August 1999): 72–6.

Halbreich, Kathy, and Vishakha N. Desai. *Connections: Martin Puryear*. Exh. broch. Boston: Boston Museum of Fine Arts, 1990.

Hanhardt, John G., et al. *1979 Biennial Exhibition*. New York: Whitney Museum of American Art, 1979.

Hanhardt, John G., et al. *1981 Biennial Exhibition*. New York: Whitney Museum of American Art, 1981.

Herbert, Robert L., and Paul Staiti. *Collective Pursuits: Mount Holyoke Investigates Modernism*. Exh. cat. Norwich: The Trustees of Mount Holyoke College, 1993.

Hughes, Robert. "Delight in a Shaping Hand." *Time*, March 2, 1992, 61–2.

Hughes, Robert. *American Visions: The Epic History of Art in America*. New York: Knopf, 1997.

Hunter, Sam, and John Jacobus. *Modern Art*. 3rd ed. New York: Abrams, 1992.

Joachimides, Christo M., and Norman Rosenthal. *American Art in the 20th Century: Painting and Sculpture, 1913–1993*. Berlin, London, and Munich: Zeitgeist-Gesellschaft, Royal Academy of Arts, and Prestel, 1993.

Johnson, Diana L., and Gregory Wallace. *Reprise: The Vera G. List Collection: A Twentieth Anniversary Exhibition*. Rhode Island: Brown University, 1991.

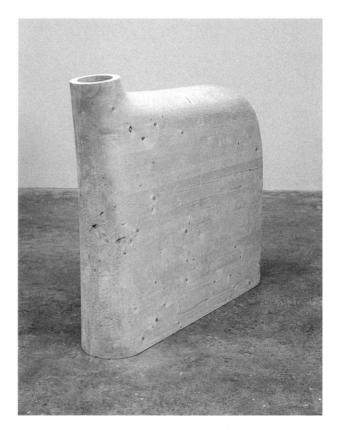

Fig. 20
IN SHEEP'S CLOTHING, 1996–98
French pine
53 1/2 x 62 3/4 x 13 1/2 in. (135.8 x 159.3 x 34.3 cm)
The Des Moines Art Center, Des Moines, Iowa
Purchased with funds from the Coffin Fine Arts Trust; Nathan Emory Coffin Collection of the Des Moines Art Center

Kangas, Matthew. "Martin Puryear: The Rematerialization of the Art Object." *Sculpture* 16 (July/August, 1997): 61–2.

Kawaguchi, Yukiwa, et al. *American Stories: Amidst Displacement and Transformation.* Exh. cat. Tokyo: Cultural Projects Division, 1997.

Kimmelman, Michael. "Review/Art: Martin Puryear." *The New York Times,* December 2, 1988, sec. C, 24.

___. "The Softly Spoken Message of Martin Puryear." *The New York Times,* March 1, 1992, sec. H, 35.

___. "Martin Puryear." *The New York Times*, March 10, 1995, sec. C, 20.

___. "Abstraction, Without the Mess." *The New York Times,* February 11, 1996, sec. C, 1.

King, Elaine. "Beyond Style, the Power of the Simple." *Martin Puryear: Sculpture and Works on Paper.* Exh. broch. Pittsburgh: Carnegie Mellon University, Hewlett Art Gallery, 1987.

Kirshner, Judith Russi. "Martin Puryear in the American Grain." *Artforum* 30 (December 1991): 58–63.

___. *Options 2: Martin Puryear.* Exh. broch. Chicago: Museum of Contemporary Art, 1980.

Kline, Katy, and Douglas Dreishpoon. *Natural Forms and Forces: Abstract Images in American Sculpture.* Exh. cat. Cambridge: Massachusetts Institute of Technology, List Visual Arts Center, 1986.

Knight, Christopher. "Monumental Greeting." *Los Angeles Times,* November 26, 1999, sec. F, 1.

Koplos, Janet. "Sculpture's Surfaces, East and West: Considerations on Form and Materials." *Surface Design,* Fall 1999, 36–41.

Krainak, Paul. "Contraprimitivism and Martin Puryear." *Art Papers* (U.S.A.) 13, pt. 2 (March/April 1989): 39–40.

Lautman, Victoria. "Martin Puryear: Chicago Public Library Cultural Center." *Sculpture* 6, no. 4 (July/August 1987): 28–9.

Lewallen, Constance. *Martin Puryear: Matrix/Berkeley 86.* Exh. cat. Berkeley: University of California Berkeley Art Museum, 1985.

Lubowsky, Susan. *Enclosing the Void: Eight Contemporary Sculptors.* New York: Whitney Museum of American Art, 1989.

Lucie-Smith, Edward. *Movements in Art Since 1945: Issues and Concepts.* London: Thames and Hudson, 1995.

Madoff, Steven Henry. "Sculpture Unbound." *ARTnews* 85, no. 9 (November 1986): 103–9.

Marcoci, Roxana. "The Anti-Historicist Approach: Brancusi, Our Contemporaries." *Art Journal* 59, no. 2 (Summer 2000): 18–35.

"Martin Puryear La grace." *Figaroscope,* du 6 au October 12, 1999: n.p.

McAllister, J., ed. *Hirshhorn Museum and Sculpture Garden: 150 Works of Art.* Washington and New York: Smithsonian Institution/ Abrams, 1996.

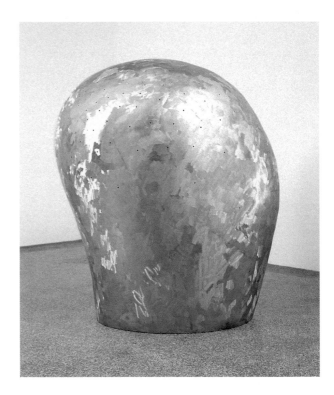

Fig. 21
UNTITLED, 1997
Copper
65 x 54 1/2 x 48 1/2 in. (165.0 x 138.3 x 123.1 cm)
Collection of the Albright-Knox Art Gallery

McShine, Kynaston. *An International Survey of Recent Painting and Sculpture*. New York: Museum of Modern Art, 1984.

Melrod, George. "The Art of the Decoy." *Sculpture* 10, no.5 (September/October 1991): 32–9.

___. "Searching for a Center." *ARTnews* 92, no. 8 (October 1993): 117–8.

___. "Skill, Vision and Craft." *Art & Antiques* 18 (September 1995): 39–40.

Morgan, Ann Lee. "Martin Puryear: Sculpture as Elemental Expression." *New Art Examiner,* May 1987, 27–8.

Naves, Mario. "Martin Puryear." *The New Criterion* 13, no. 9 (May 1995): 47–8.

Newman, Sasha N., and Lesley K. Baier, eds. *Yale Collects Yale.* New Haven: Yale University Art Gallery, 1993.

Nuridsany, Michel. "Martin Puryear: la séduction de la spiritualité." *Le Figaro/Aurore,* September 28, 1999.

Paddon, Thomas. "Martin Puryear." *Sculpture* 14 (May/June 1995): 42.

Pallister, K.C. *Wanås 1996*. Exh. cat. Knislinge: Wanås Foundation.

Patton, Sharon F. *African-American Art*. New York: Oxford University Press, 1998.

Philips, Patricia C. "Museum of Fine Arts, Boston; Installation." *Artforum International* 29 (October 1990): 172–3.

Phillips, Lisa. *The American Century: Art & Culture, 1950–2000*. Exh. cat. New York and London: Whitney Museum of American Art in association with W. W. Norton & Company, 1999.

Plagens, Peter. "Sculpture Like it Oughta Be." *Newsweek,* November 11, 1991, 73.

Princenthal, Nancy. "Intuition's Disciplinarian." *Art in America* 78 (January 1990): 130–7.

___. "Martin Puryear." *American Craft* 52 (February/March 1992): 34–7.

"Puryear Courtyard for New School." *Art in America,* February 1998, 29.

Rasaad, Jamie. "Making It in the American Grain." *The Times of London Literary Supplement,* September 25, 1992, 21.

Richard, Paul. "Martin Puryear: A Master in Wood." *International Herald Tribune,* February 15–16, 1992.

Riggs, Thomas, ed. *St. James Guide to Black Artists*. Detroit and London: St. James Press, 1997.

Rose, Bernice. *Allegories of Modernism: Contemporary Drawing.* New York: Museum of Modern Art, 1992.

Rosenthal, Mark. *Abstraction in the Twentieth Century: Total Risk, Freedom, Discipline*. Exh. cat. New York: Solomon R. Guggenheim Foundation, 1996.

Rossignol, Pascale. "Martin Puryear." *Art Press* 252 (December 1999): 84–5.

Rowlands, Penelope. "Living with Art: Steven and Nancy Oliver." *ARTnews* 97, no. 3 (March 1998): 104–8.

Rubin, William S. *Primitivism in 20th Century Art: Affinities of the Tribal*. New York: Museum of Modern Art, 1984.

Sandler, Irving. *Art of the Postmodern Era: From the Late 1960s to the Early 1990s*. New York: HarperCollins, 1996.

Schwabsky, Barry. "The Obscure Objects of Martin Puryear." *Arts* 62 (November 1987): 58–9.

___. "Report from Sweden: Surrounded by Sculpture." *Art in America* 87, no. 1 (January 1999): 57–9.

Scott, Sue, and Betsy Gwinn. *The Edward R. Broida Collection: A Selection of Works*. Florida: Orlando Museum of Art, 1998.

Shapiro, Michael Edward. *New Sculpture/Six Artists*. Exh. broch. Missouri: Saint Louis Art Museum, 1988.

Shearer, Linda. *Young American Artists, 1978 Exxon National Exhibition*. Exh. cat. New York: The Solomon R. Guggenheim Foundation, 1978.

Swift, Mary, and Clarissa Wittenberg. "An Interview with Martin Puryear." *The Washington Review,* October/November 1978.

Thompson, David N. "Art Institute of Chicago: Traveling Exhibition." *Arts Magazine* 66 (February 1992): 70.

Tomkins, Calvin. "Perception at All Levels." *The New Yorker,* December 3, 1984, 176.

Turrell, Julia Brown. *Individuals: A Selected History of Contemporary Art, 1945–1986*. Exh. cat. Los Angeles: Museum of Contemporary Art, 1986.

Vogel, Susan, Daniel Shapiro, and Jack Flam. *Western Artists, African Art*. New York: Museum of African Art, 1993.

Waldman, Diane. *Transformations in Sculpture: Four Decades in American and European Art*. New York: Solomon R. Guggenheim Foundation, 1985.

___. *Emerging Artists 1978–1986, Selections from the Exxon Series*. Exh. cat. New York: Solomon R. Guggenheim Museum, 1986.

Warren, Lynne, et al. *Art in Chicago: 1945–1995*. Chicago: Museum of Contemporary Art, 1996.

Waxman, Sharon. "Getty, on the Grow." *The Washington Post,* December 12, 1999, sec. G, 1.

Wheeler, Daniel. *Art Since Mid-Century: 1945 to the Present*. New York: Vendome Press, 1991.

Wolf, Laurent. "Un escalier pour monter jusqu'au ciel." *Le Samedi Culturel,* October 23, 1999.

Wood, Carol. "Martin Puryear." *New Art Examiner* 22 (May 1995): 51–2.

Wood, J., and Teri J. Edelstein. *The Art Institute of Chicago: 20th Century Painting and Sculpture*. Chicago: Art Institute of Chicago, 1996.

Young, Louis, ed. *The Decade Show: Frameworks of Identity in the 1980s*. New York: Museum of Contemporary Hispanic Art and The Studio Museum of Harlem, 1990.

Zakian, Michael. "Culture Clash." *Artweek* 30 (October 8 1992): 26–7.

PHOTOGRAPHY CREDITS

All works of art by Martin Puryear appearing in this catalogue are copyrighted by the artist. Images of these works are copyrighted by the owners and photographers of individual works and thus may not be reproduced in any form without the permission of the copyright owners.

Ray Andrews: fig. 20

Dirk Bakker, © The Detroit Institute of Arts: cat. no. 9 (detail)

Courtesy The Baltimore Museum of Art: cat. no. 1

© Eduardo Calderon, courtesy Donald Young Gallery, Chicago: figs. 13, 21; cat. no. 9 (full view)

Lynn Davis, © J. Paul Getty Trust: fig. 12

© Jeff Goldberg/Esto: fig. 8

© Michael Korol, courtesy McKee Gallery, New York: cat. no. 11 (full view)

Robert Lantman, courtesy McKee Gallery, New York: fig. 18

Paul Macapia, © Seattle Art Museum: cat. no. 3 (detail)

Courtesy McKee Gallery, New York: figs. 10, 11, 17; cat. no. 8

Robert Newcombe, © The Nelson Gallery Foundation: cat. no. 5 (detail)

© Douglas M. Parker, courtesy Margo Leavin Gallery, Los Angeles: figs. 1, 4, 15

Courtesy The Saint Louis Art Museum, Bob Kolbrener (full view) and David Ulmer (detail), © The Saint Louis Art Museum: cat. no. 2

© Michael Tropea, courtesy Donald Young Gallery, Chicago: fig. 5; cat. no. 3 (wide and narrow views)

© Sarah Wells, courtesy McKee Gallery, New York: figs. 9, 14; cat. no. 4 (full views and detail); cat. no. 5 (full view); courtesy Mr. and Mrs. Robert W. Truland: fig. 6

Katherine Wetzel, © Virginia Museum of Fine Arts: cover and page x (details); cat. no. 6 (full view); cat. no. 7 (detail and full view); cat. no. 10 (full view and details); cat. no. 11 (details); cat. no. 12 (full view and details)

Donald Young, Courtesy Donald Young Gallery, Chicago: fig. 3

Courtesy Donald Young Gallery, Chicago: figs. 2, 7, 16, 19